PRACTICAL MANUAL OF
CAPTIVE ANIMAL
PHOTOGRAPHY

Michael Havelin

AMHERST MEDIA, INC. ■ BUFFALO, NY

DEDICATION

To all my fellow creatures: the finned, the winged, the no-legged, the two-legged, the four-legged, the six-legged, the eight-legged, the flagella'd, and all the others. This book would have never been needed without you. Thanks for the inspiration and cooperation. Thanks for being there.

All photographs by Michael Havelin.
Pen and ink illustrations by Erin Coffin.

Published by:
Amherst Media, Inc.
P.O. Box 586
Buffalo, N.Y. 14226
Fax: 716-874-4508
www.AmherstMediaInc.com

Publisher: Craig Alesse
Senior Editor/Project Manager: Michelle Perkins
Assistant Editor: Matthew A. Kreib

ISBN: 1-58428-023-9
Library of Congress Card Catalog Number: 99-76587

Printed in the United States of America.
10 9 8 7 6 5 4 3 2 1

TABLE OF CONTENTS

ACKNOWLEDGEMENTS

Charlie Green of Asheville, North Carolina. I first met Charlie when he came to the Western North Carolina Nature Center to take one of my nature photo workshops. Trained as a nurse, Charlie's passion is turtles. We developed a solid friendship and shared lots of photographic and animal adventures over a lot of geography since. Thanks for everything, Charlie, mostly the friendship.

Perfect Pets Enterprises in Mableton, Georgia, a family-owned pet shop (not a chain), where I was able to do some of the photography for this book.

Pine Mountain Wild Animal Park (Wild Animal Safari) in Pine Mountain, Georgia. A truly thrilling place that gives kids and adults the opportunity to meet face-to-face (meant most literally) and hand-feed zebra, giraffe, bison, watusi, ibex, and more. Sorry, no hand-feeding the lions. Take your kids or grandkids and watch them light up.

Riverbanks Zoological Park in Columbia, South Carolina. A great zoo with everything from tigers to jellyfish. It's well laid-out with obviously well cared-for creatures. The staff is extremely knowledgeable and helpful.

The Tennessee Aquarium in Chattanooga, Tennessee. If you've never been there, stop what you're doing right now and go. You'll never be the same. This is a magical place on our planet, one of the current Seven Wonders, in my humble opinion. Their exhibits are astonishing, the scope of their coverage remarkable. Recommended for all ages.

The Western North Carolina Nature Center, where I was able to work out many of the technical approaches presented in this manual. Thanks for your help and encouragement.

Zoo Atlanta in Atlanta, Georgia. A long-lived, big city zoo that helps legitimate projects whenever possible. Thanks, folks.

Erin Coffin for her quality pen and ink illustrations.

And last but not least, thanks to my publisher, Craig Alesse of Amherst Media, Inc. It never would have happened without you.

Thanks to all y'all.

1
PHOTOGRAPHIC GOALS & ETHICAL DILEMMAS

☐ The Goal of the Great Image

Why does someone start out doing nature and wildlife photography in the first place? As an excuse to be out-of-doors without having to hunt or fish? To impress friends and family? To get away from a bad home situation? To make pretty pictures? It might even be with the lofty goal of saving the planet. How about the practical goal of earning a living at a craft that's creative and exotic, and sometimes tedious but sometimes incredibly exciting?

The goals of animal photography are simple:

1. To get a great picture of a living creature, with minimal danger to yourself or the creature.

2. To capture the animal in as natural an environment as possible.

3. To make more than a mere record shot by capturing significant behaviors or interactions.

That all sounds simple enough, but the getting of those exceptional photographs is fraught with pitfalls, ethical as well as technical, and that means you've got to learn how to do it right. There's a lot to it, more than just buying the latest, hottest, don't-think-just-push-the-button photo gear, running up $1000 worth of film and a ticket to the Galapagos on your most recent credit card, and heading off into the sunrise.

You've got to master photographic technique, and you've got to learn how to see with new eyes. But that's only the beginning. You've also got to become a naturalist, if you weren't already. You have to learn about your subjects, their habitats, the dangers they face in nature everyday of their lives, and the species and environmental dangers we humans have added to the equation.

If you're shooting for publication, you've also got to learn about how to do photographic

"The goals of animal photography are simple..."

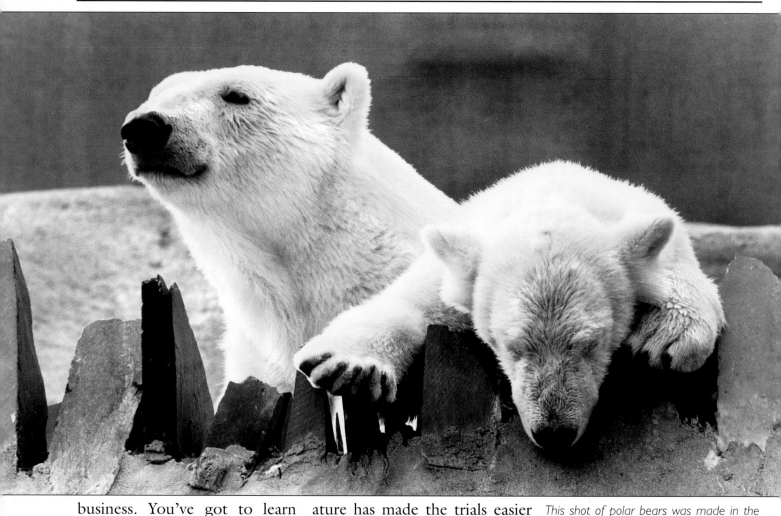

business. You've got to learn about model releases, liability insurance, the law of trespass, the specific and anarchic rules of various refuge and national parks managers, selling limited rights for specific picture usage, all about copyright law, and about how to collect from late-paying photo buyers. And on top of all that, you must begin to make ethical decisions before and after you release the shutter. Still want to do it? Strap on your crampons and start climbing that learning curve, gang.

For someone learning on his own like I did, much of all that's a trial-and-error process. But over the last ten years or so, a growing body of technical liter-ature has made the trials easier and many of the errors avoid-able. Several publishers (All-worth Press, Amherst Media, Amphoto, and Focal Press, to name a few) have produced libraries of technical books aimed specifically at the nature and wildlife shooter. Writers and teachers like John Shaw, Joe McDonald, Irene Sacilotto, and others have emerged from the herd and become famous for their workshops as well as their remarkable photography.

If you're among those peo-ple who have the time and money to buy the big glass and go on expensive photo junkets to the untrammeled corners of the earth where animals are less

This shot of polar bears was made in the London Zoo back in the early 1970s but it remains one of my favorite pictures. If I'd only known what I was doing at the time…

"How can we solve this dilemma?"

wary of humans, and if you're willing to suffer danger with equanimity, personally feed hordes of mosquitoes and biting flies, and sit in hides without restrooms for days at a stretch, it's possible to get great images. But for most people of limited means and time who have more or less normal temperament, it's extremely difficult to get the kind of shots we think of in our mind's eye. Living in North America and Europe, as many non-professional shooters do, the animals either aren't there for us, they are so wary that they successfully avoid all human contact, or myriad other difficulties make getting great pictures virtually impossible. How can we solve this dilemma?

Even with all the teaching and learning that's been going on, there are still some secrets to making great animal imagery, well-kept secrets that people sometimes share, but few employ anyway. There's nothing too arcane about these secrets,

Left: The picture is not totally in focus, but the eyes are sharp. This makes all the difference between a throw-away junk shot and a keeper. Hey, it was used in a book on captive animal photography!

Below: It's not always possible to shoot with only the available tank light, but it worked out in this case using Tri-x film exposed at ISO 320. I shoot it a little slower than the recommended ISO 400 to get more shadow detail. Always watch out for backgrounds that are too busy, as in this shot. Burning the background in during printing helps, but not quite enough for my taste.

and they fall into two major categories: shooting big critters, and shooting small ones. We need to look at both.

Whether shooting big or shooting small, the simple answer is to shoot pictures of animals that we can find and which can't evade us. Simply stated, this means shooting captive creatures. Okay, now we're on the shaky ethical ground. What's the problem? I'll tell you.

☐ Ethical Dilemmas

In recent years, it was noticed that people have put pressures on animals in the national parks and national wildlife refuges, and that this had changed the animals' behaviors. Of course, this included tourists, but the more serious pressure was being put on the animals by photographers. Why? Because the photographers all wanted to get closer to the animals for more telling imagery, to get those more impressive shots. The ani-

mals first reacted in their movement patterns, then their feeding and socialization behaviors, and this in turn led to changes in sexual and thus breeding behaviors. The animals' mental health, sometimes their very survival, was in jeopardy. Something had to be done.

In the old days, it was perfectly acceptable to stick a lens into an animal's face and fire off a couple of rolls of film. The animal's feelings were not considered much, if at all, except when a pressured animal took a run at the invasive shooter. That's no longer accepted as a responsible way to get pictures. The animals must be considered. Even more, concern for the animals has become the overriding factor in wild animal photography.

In 1993, more than 100 nature photographers, professionals and hobbyists, met to discuss the problems facing nature photographers. The result was that The North American Nature Photography

"The animal's feelings were not considered much, if at all..."

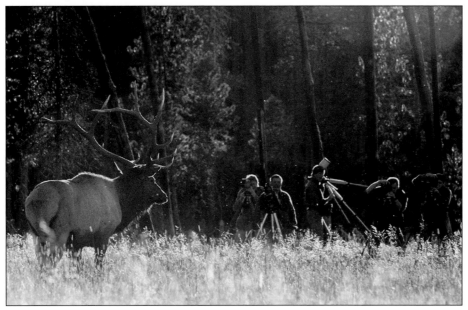

At Yellowstone National Park, massed photographers are all out for that quintessential elk shot, but all the pictures tend to look the same. And animal behavior will be changed by "photo-pressure."

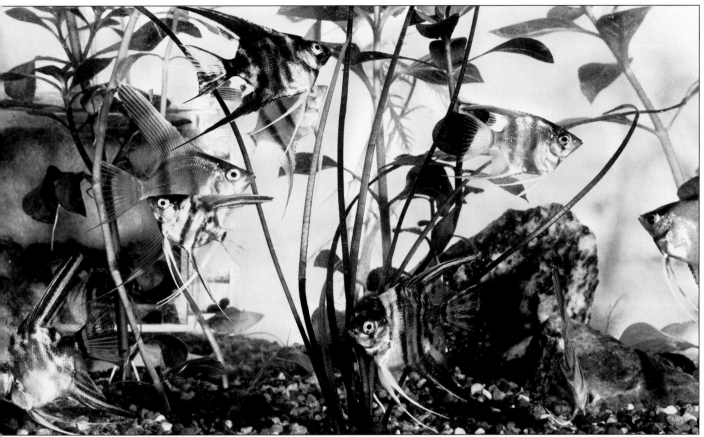

Here's your most basic fish tank shot, but even here subtleties abound. Watch out for disturbing elements in the background like that big filter box on the left. Exposure is also a problem. The in-camera meter can be easily tricked by the white wall behind the tank. So what do you meter? The gravel? The large rocks? The very small and contrasty black and silver angel fish? Try it. And take notes as you go.

Association (NANPA) was established in 1994. Non-profit status was sought and committees were set up. The organization was on its way.

One of the major things this outfit did was to encourage a more ethical approach to photographing animals. Less pressure equals happier critters. Happier critters equals better karma and less hassle from park management. It also equals more photographic problems for those who don't have that expensive, long, big front aperture glass.

We all need to applaud NANPA's work. They have increased awareness of the problems nature photographers face, and have established standards that we all need to aspire to. They have also made serious inroads as an organization

speaking for photographers' concerns.

During the same period, the nature photography "purists" also emerged. It was these people's adamant position that the animals' well-being was the primary concern, and that anything which stressed an animal out was *verboten*. Well, just as in any highly charged debate (i.e. abortion or euthanasia), you're going to have a spread of opinion from those who are most radical to those on the other end who are most conservative, and everyone else will take a stand someplace along the continuum between.

I have to agree with the purists to a major degree, but I limit my agreement to animals in the wild. There is another class of creature which seems to

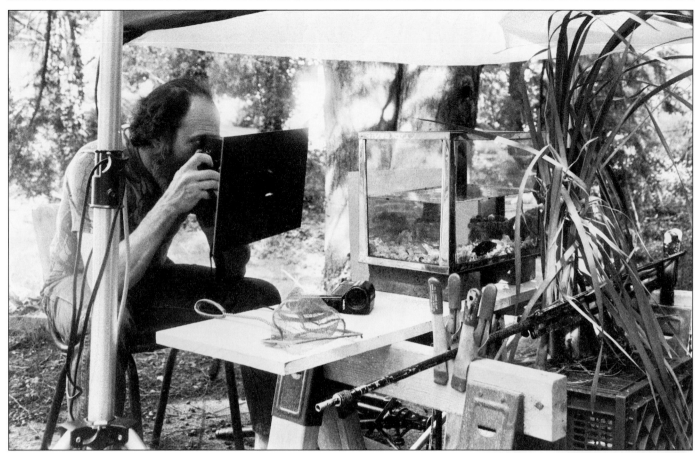

have largely been ignored in the whole debate, except by animal rights groups: animals who were already contained (all right, say "prisoners") in zoos, breeding facilities, animal repair facilities, pet shops, private collections, and elsewhere.

☐ Proposed Solutions

With the proliferation of auto-everything cameras, the technical aspects of photography have become much less of a hurdle for people to surmount. (I believe you should understand your craft so you know what the camera's brain is trying to do and when you must override the auto-technology, but that's my own personal issue.)

What remains after conquering photographic technology are the problems of dealing with the animals themselves: getting close enough, capturing their behaviors, and leaving them to carry on their lives more or less normally after the photo session has ended.

In the national parks, particularly in the Western United States, photographers are pretty much free to wander at will and hardly a year goes by without a photographer being killed or seriously injured because he/she pressured an animal beyond the animal's tolerance. When cornered, even the common gray squirrel can do significant damage to mere human flesh. Grizzlies are particularly noted for their unforgiving attitude. So what's a poor struggling photographer supposed to

We decided to photograph a baby snapping turtle in Charlie's backyard one summer's day. A small tank was set up with a large rock inside to limit the turtle's swimming area. A large soft box with a studio flash was rigged overhead, balanced to provide light at the same level as the ambient daylight. For a background, several cattail fronds were clamped to a light stand held horizontal on the saw horses by several more clamps. The reflection killer was used on the front of my 105mm macro lens. It's all illusion, folks.

do after investing so much time, effort, and money in photography? How are we to get the award-winning pictures we crave?

My solution to the seemingly insoluble photographic problem of getting close to animals for telling photographs, already stated above, was to seek out those locations where animals were already contained, where I could get permission to get at them, and where the people in charge (as well as the animals) were approachable. I went to the zoos, nature centers, wild animal parks, animal repair facilities, pet shops, and breeders, and I started to get some great images. You can do it too.

Because of my stance on this, this book will probably raise a few eyebrows among certain groups and people, but in the practical world of rules and limited access, whatever the reasons for those limitations, you're going to learn how to get the great photos you seek.

Most of what you need to know is standard photographic technique that's been around for years. What you'll be doing differently is applying these techniques to living things instead of to bottles of perfume or nuts and bolts like advertising and industrial photographers regularly do.

The big trick is in finding where the creatures are, and then getting through whatever bureaucratic maze needs to be navigated to make meaningful shots without danger to the ani-

mals or yourself. That's what this book is all about; we're looking at shooting in controlled environments, not in the wild.

How are great animal shots achieved? Well, if you think that the full-face shot of a mountain lion on the cover of the latest issue of your favorite photography magazine was done in the wild, you're wrong. A shot like that can only be obtained in a captive situation.

☐ The Captive Situation

A captive situation is any situation where you can work with an animal that is not free-roaming. Typical captive situations include, but are not limited to: zoos, safari parks, nature centers, aquariums (commercial and home), terrariums, pet shops, wild animal repair facilities, veterinary or research institutions, trout hatcheries, and farms. Even domestic pets like cats and dogs are captive animals, though you might not usually think so because they tend to run the place. In your home area, there are undoubtedly some great reptile specimens being kept by herptile hobbyists. A local pet shop specializing in that type of animal or a local exotic animal veterinarian will probably know who these people are. Start asking around. You'll be amazed what you find.

Captive specimens are much more accustomed to people than their wild counterparts, even those in the national parks.

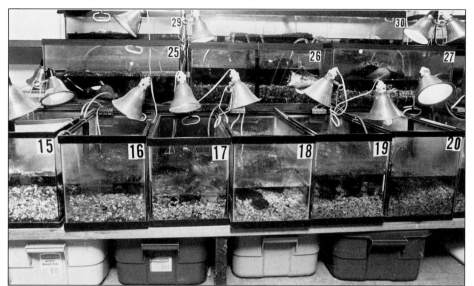

Left: One bank of tanks in turtle specialist Charlie's Green's breeding room. Not exactly set up for photography, but a great place to do set-ups with a large variety of species in one facility and easily adaptable to photographic work. Humidity was a killer though, and all my equipment had to be thoroughly dried out when the photo session was over.

Below: A pair of adult lions in repose at Zoo Atlanta. This shot was made about fifteen minutes after the zoo first opened its gates, before the busloads of school kids arrived to change the ambiance to one of chaos and noise.

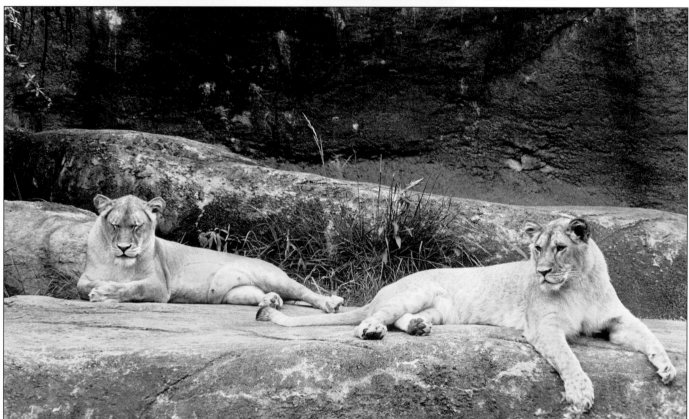

They are used to seeing people, and are used to being confined in a limited space. They may well be used to being handled as well. Their keepers know their personalities. In short, they are very approachable. You might not get the great mating shot or other wild interactions, and you have to be very careful of your backgrounds, but you will always be able to go home with amazing face shots, true animal portraits that are exactly what's needed for display and for sale. As long as you don't represent your captive shot as having been made in the wild, it's the end picture that counts, right?

2
PHOTOGRAPHIC RESPONSIBILITIES

Just because you can afford a decent camera and a few rolls of film and processing doesn't mean that you should be loosed on the world calling yourself a wildlife photographer. Freedom comes with responsibilities, on many different levels, and photographic freedom has its own ethical burdens. Let's look at several in turn.

☐ Responsibility To Creatures

If you're going to shoot pictures of living things, they must be respected, even protected. Your activities will benefit you, whether you sell the resulting images or just hang them on your office walls. If there's no direct benefit to your creature subjects, they should at least not be damaged in any way, physically or psychologically.

How were your images obtained? At the cost of stress to the animal subject? At the cost of its feeding behavior for the period you interacted with it? At the cost of the public expo-sure of its previously unknown and undisturbed favorite loca-tion? At the loss of its mating opportunity for that day?

The creatures you photo-graph have to be paid off prop-erly. That means that you must respect them as fellow creatures on this amazing planet of ours. Even an attacking grizzly has a right to that attack if you've been bothering her. We all live here together, folks.

Not to be a old fuddy-duddy, but I believe that the Golden Rule that we all learned as kids is still the best approach when dealing with other living things: do unto others as you would have them do unto you. That goes for animals as well as people. (Plants too as far as pos-sible, but that's for another book.)

☐ Responsibility To Editors

The ability to communicate carries with it responsibility to your audience, at whatever level you encounter it. The first level

"Freedom comes with responsibilities..."

of audience you'll meet is usually the editor or photo buyer who's going to make the decision whether to use your work or not. Your responsibility to these people is to tell them the truth.

The truth doesn't come in a variety of flavors, although some people would say that there are degrees of truth. They divide it all up into fibs, white lies, sometimes true, mostly true, probably true, true at the time it was first said, and absolutely true. And since there's something in law called a "legal fiction," there's undoubtedly a "legally true" category as well. In a Victorian novel I once read, a character referred to another as "mistruthful," a liar, in other words.

You may tell an editor that a shot was made under captive conditions and later see the shot in print somewhere captioned incorrectly. Basically, once you've done your part, it's out of your hands. What the editor decides to do with your material is beyond your control. You could demand a correction, but the damage, including to your reputation, may well have been done. You might decide not to do business with that editor again, as I once decided. The truth was more important to me than ongoing access to a major national market. Did I make the right decision, or was I naïve and idealistic? To my mind, without idealism we're nowhere. The same goes for truth.

You'll have to decide on your own integrity. It's your character.

☐ Responsibility to the Public

To my mind, as photographers of living things we're in the business of educating the world. Children and adults look to us, the curious and adventurous image makers, for their knowledge of the world and its creatures. Are we going to spread myths and untruths? Or are we going to help people understand their world better by telling them what's really going on?

I take this responsibility seriously, and although photography is great creative fun, I hope you do too. Always do the best and most complete job of presentation you can. After that, your work's pretty much done. It's then up to the audience how much they will pay attention and absorb. We can only do as much as we can do.

☐ Responsibility To Yourself

You've got to live with yourself. You might be able to fool editors and photo buyers, your significant other, and the public, but you'll never fool yourself. You know what's right and wrong behavior, can learn from your mistakes, and improve your judgment over time.

For me, this means that I've got to walk a straight line between the truth and my wallet. An extra few dollars reward for telling a little fib isn't worth it to me, although I know there

"Are we going to spread myths and untruths?"

"... the reputation for honesty is easily lost..."

are people out there who prefer the dollars in their pocket and the truth be damned. Oh, well. Nothing I say in print will influence those folks anyway.

But character is on the line here, and the reputation for honesty is easily lost and never recoverable. Integrity has been compared to virginity that way, and it's true. Lose it a little and you've lost it all. If your character and reputation are unimportant to you by the time you read all my moralizing, it's too late anyway.

As for the rest, allow me a rare moment of spiritual soapboxing. This is an amazing planet and we all live here together: mammals, fish, reptiles, birds, insects, and plants. Even viruses have a place, though we might not understand it fully. The earth is a island of life in an empty void, and we need to appreciate our uniqueness. Respect the earth and your fellow creatures. It's okay to kill a mosquito or deer fly occasionally, but do it with the knowledge that you are snuffing out an independent and remarkable life.

For those of you who are comfortable with doing the right thing, more comfortable than doing wrong things, I applaud you and your ethics, and there's nothing to worry about, right? For the others? Good luck.

3
LEGALITIES

We live in a litigious society. Everyone seems to want a piece of what other people have and many people are willing to sue at any opportunity, tenuous though the reason might be. In such a legal environment, however ill-conceived, we must try to protect ourselves as best we can. This means that we have to pay attention to the consequences of our actions before we act, and carry liability insurance for our inadvertent mistakes.

The best medicine is prevention though, and in having good relationships whenever possible. Yes, it's difficult, human nature being what it is, but we need to continue doing our personal best anyway. I find it a continual challenge.

☐ Courtesies to Venues and Organizations

Try to maintain good relations with organizations and locations you visit. This means to follow normal business cour-

tesy at a minimum, and where possible and appropriate, go a bit further. It might mean sending seasonal greeting cards, e-mails, or thank you notes for assistance given. I've even sent people who've helped me copies of articles I've come across which they might find interesting.

The bottom line is, don't be a jerk any more than is absolutely necessary. Your courtesies will make a return trip easier for you and possible for the next photographer to come along. We're all in this together, folks. Don't be the one that people complain about; "Oh, we don't allow that level of access for photography any more. The last guy alienated the staff and left a real mess. I don't know why all you people are so arrogant." It's great to be remembered, isn't it?

☐ Permission to Shoot

Before descending on a venue with your personal agenda and all your gear to create

"... maintain good relations with organizations you visit..."

18

photographic havoc, call ahead to make appropriate arrangements. Conditions may have to be agreed to, special permissions obtained from those in charge, and staff schedules adjusted to accommodate your visit.

Unfortunately, there is no single set of guidelines that applies to all organizations and institutions. Each has their own view of the world, their own internal mechanisms, their own interdepartmental politics, their own unique sensitivities, agendas, fetishes, and idiosyncrasies. They must be courted individually, like magazine editors. Try to remember that your personal project is more important to you than to them.

Garrison Keeler says "It's easier to be forgiven than to get permission." That's great humor, but less than great advice in the real world. As little as we might like it, there are sometimes hurdles that need to be jumped.

□ Permission to Use the Pictures

Even though you might get permission to go in and shoot, the use of the resulting images might be a totally different thing. Remember the "unique sensitivities, agendas, fetishes, and idiosyncrasies" from two paragraphs ago? But here's an edge.

Everyone is looking for publicity. To paraphrase a famous quote: "I don't care what you say about me as long as you spell my name right." Who said that? Oscar Wilde, Mae West, or P.T. Barnum? Anyway, many institutional minds think same way. If you can get them permanent exposure in your article or book with proper credit, they will generally be far more willing to help out, or at least to not put additional obstacles in your path.

□ Model Releases

It used to be that you only needed to get a signed release from individuals (humans, that is) who would be recognizable in your picture and if the photo was to be used for "trade purposes." This is no longer the case. The world has become far more complicated.

In captivity or in the wild, animals don't have to sign releases. Their paw prints would be difficult to obtain. The obvious exception to this is if the animal is easily recognizable and the image will used for a commercial purpose (advertising, product endorsement, etc.). An example would be using a photo of Lassie to sell dog food. Wedding photographers nowadays regularly get releases from the bride and groom and everyone else they can nail down so they can use the wedding photos for their own promotional or stock photo purposes. The same applies here.

How about the animal handlers? Will they be recognizable? Was the picture shot in a "breaking news" situation? Are you going to sell the images for

"Conditions may have to be agreed to, special permissions obtained..."

advertising purposes later? Sometimes you don't know until years later that the picture has a commercial marketability.

What about the facilities where the creatures were photographed? Are they unique enough to be recognizable like Sea World or Zoo Atlanta? If private or institutional property appears, did you have permission to shoot in the first place? Did you get it in writing?

As you can see, there are lots of questions around the topic of model releases. The list of issues cited doesn't begin to cover everything. And worst of all, if you asked a gaggle of attorneys you'd only get a gaggle of answers. What is a struggling photographer to do?

My suggestion is simply to be paranoid. A little healthy paranoia can save you lots of grief later on. If you have any doubt, get a release. It can't hurt. I tend to get releases most of the time these days. You never know where the pictures might end up. For the most part, people tend to be cooperative if they perceive that you're working on a legitimate project. There are plenty of sources for examples of personal and property releases for you to choose from, so one hasn't been included here. Check the bibliography at the back of this book.

"My suggestion is simply to be paranoid."

4
SELLING YOUR WORK

☐ The "Big" Picture

Are you still waiting for that one great image that's going to make your reputation and fortune? Stop waiting. Stop hoping. Stop dreaming. There ain't no such thing.

Who are the guys who known for great imagery? Abraham Zapruder? Yes, for his once-in-a-lifetime 8mm film sequence of President Kennedy being shot in Dallas on November 22, 1963. Did you ever hear of Zapruder again? Not for any more photographic work he did. Okay, he was a special case because he was a dry-cleaner who happened to be in the crowd that day. By the way, there's now a movie out about his big day in Dallas. Who would've guessed?

But what about people like Heather Angel, Jim Brandenburg, David Doubilet, and Galen Rowell? Did individual images make these folks? Again the answer is no. Their reputations were made by skill, knowledge, and persistence that resulted in a body of work over the course of years. And that's where it's at. Yes, there are famous images made by each these people, but photographic excellence is measured in consistency and staying power, not by isolated or freak images.

So how are you going to become rich and famous at animal photography? You could do it the way that Walter Chandoha did: once again, by persistence and skill over the course of a lifetime career. He's been shooting domestic pets since... well, for many years.

Of course, it's still possible to make a small fortune in nature photography. Just start out with a large fortune. That's what I did, and it worked.

☐ The Photo Story

I'm an advocate of combining writing and photography to create salable text and photo packages. I even wrote a book on the subject.

"Their reputations were made by skill, knowledge, and persistence...."

One reason for my words-plus-photos philosophy is that the average editor doesn't want to see a single isolated image with no supporting material. Having said that, it also must be said that there are times when full text is inappropriate.

If you don't have a facility with words yourself, or can't find a writer-ally, or if the subject matter itself suggests a photo story rather than a full-blown text-photo package, stop thinking in terms of a single picture and start thinking in a series of images that tells the full story. That would be the way to go. Let's face it, a picture may be worth 1,000 words, but a coherent group of pictures that tell a complete tale might be worth $1,000 or more.

What should you include in a photo story? The basics are simple: overall shots to set the scene, details to complete the information. What you do within that standard formula will be defined by your viewpoint, creativity, and obsessiveness. Your technical expertise will improve with practice, and yes, with failure. We learn from our mistakes, even if it's only to not make the same mistake again. And learn from other people's mistakes by observing what they do wrong. It's cheaper and less embarrassing that way.

Study the work of great photo essayists. W. Eugene Smith was the one who set the standard back in the 1940s when he worked as globe-hopping photojournalist for *Life* magazine. His essays are available in many texts on photography, as well as in books containing only his work. Check them out to see how it's done. He's still the master after all these years.

I have a friend who regularly shoots documentary assignments. His credo is: one for them, one for me. That means that he follows the traditional formula of overall and detail, but he also is creative with his viewpoint and approach for at least as much of the time, perhaps more. His better photography is what he shoots to satisfy his own creative needs. And many times, that's what his clients ends up using.

> "... he also is creative with his viewpoint and approach..."

Shooting the Photo Essay

(Note: some of these principles may seem contradictory, but they really aren't. Use them as a guide, not a religion. Temper them with your own experience.)

- Always think in terms of the least knowledgeable viewer of your work. What do they need to know? Shoot those images.
- The venerable journalist's saw of "Who, What, Where, When, and Why?" is always a good guide when gathering information to share with an audience. Where possible, shoot the answers to these questions.
- Shoot lots. Cover all aspects of your subject. Film is cheap.
- Distill your imagery. Include all necessary visual information in your shots.
- Edit at the front end. Exclude all extraneous visual information when composing your images.
- Edit your processed images ruthlessly before submitting them to a selected market or audience. Show only your best work at all times.
- Submit enough visual variety to give an editor choices.
- Control the editor's choices by your own ruthless editing before submission.
- Captions never hurt. Be accurate, complete, concise. Always check your facts

5
EQUIPMENT

"... learn its capabilities and idiosyncrasies inside and out."

☐ How Good Is Good Enough?

Do you need the most expensive top-of-the-line equipment to shoot great pictures of captive animals? The straight and simple answer is "no."

If great pictures are the goal, then access to subjects, patience, concentration, and lots of film are definitely required. After that, adequate and reliable equipment (not necessarily top-of-the-line gear) will do the job. This is photographic heresy (just ask anyone who sells high-end gear), but I believe that if the basics are there, it's the shooter and not the equipment that really matters.

Whatever the gear you decide on, learn its capabilities and idiosyncrasies inside and out. Learn exactly what it will and won't do. Handle it a lot, and practice with it. I once knew a guy who went out shooting all the time but we never saw any of his photos. The reason was that he never put any film in the camera. That's a great way to save money, but you can't learn about what mistakes you're making and improve your eye. I think he just wanted to meet girls.

Now let's talk about what to look for in the gear you're going to be buying and using.

☐ Helpful Camera Features
1. Full Frame Viewfinder

Most SLR cameras will have this feature, but it's good to know exactly what manufacturers mean when they use the technical term "full frame." Some cameras are made to render on film just a little bit extra around the edges of the frame than the shooter actually sees. Why is that?

In previous years, a little extra image area was built in because so much 35mm film was being shot for television use. The television frame is a slightly different shape from the 35mm frame, and to avoid loss

of image content, 35mm cameras were set up to allow for the forgetful news photographer in fast-shooting action situations. In later years, I guess it was an attempt to "idiot proof" photography for those who didn't quite understand it. For some photographic purists though, that extra little bit of image frustrates the desire to use the frame for precise framing.

Most one-hour processors also take the "idiot-proofing" approach. For example, if I shoot a tightly composed 35mm negative, those budget processor machines invariably lose the edges of my image. Sorry, but I'm from the old school and I consider composition to be a creative act. Too bad for me, eh?

2. Depth of Field Preview

This is a requirement for any type of serious photography. You have to know what you're going to get on film, and the best way to do that is to actually see it. Depth of field preview allows you to see exactly what you're going to get. Remember that the wide open aperture you view through and the stopped down aperture that the lens closes to during exposure can be very different, and what you get on film is not always what you thought you were going to get.

A camera lens sees in three dimensions: horizontal, vertical, and foreground-to-background. This foreground-to-background sharpness is what we call depth of field. Modern SLR cameras allow you to view your subject at a wide-open aperture. This is so you have lots of light for ease of composition. But a wide open viewing aperture can trick an unwary photographer because depth of field is greater when the actual shooting aperture is smaller. That's just a

This Anole was photographed in natural light, and not much of it. Slow film (Plus-X at ISO 125) didn't help either. Notice the shallow depth of field. But the face and eye are in focus enough, thus giving me a shot that is usable, at least for teaching purposes.

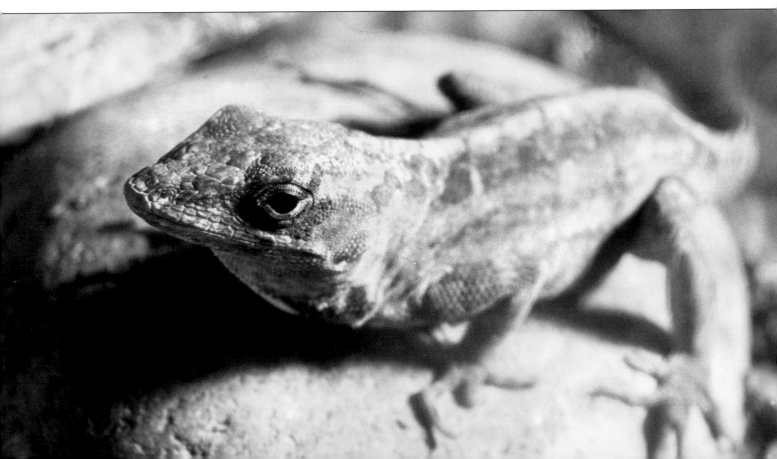

"That's just a basic rule of lens physics."

basic rule of lens physics. You don't have to be a physicist to understand this, but you have to know about it and work around the problems this optical rule can cause. Not knowing about this can ruin miles of film; knowing about it and being able to check depth of field before releasing the shutter will make you a more successful shooter.

How does depth of field affect your shooting? Here are two examples: one on the large scale, and one on a smaller scale.

On a larger scale, suppose you're at the zoo trying to get photos of a hippo in a fenced off enclosure. The fence is there to keep you out rather than to keep the hippo in. Nonetheless, the fence is a problem because you must shoot through it. It's bright midday and you must use a small aperture of f/22 to achieve proper exposure. Composing the image carefully, all you see is the hippo in its environmental surroundings. But remember that you're viewing the scene through a wide-open viewing aperture of f/2.8, and seeing it in your mind's eye as you want it to look. Without depth of field preview, you won't know that the fence pops into focus enough to ruin the photo when the aperture is stopped down to f/22. More film, time, and effort wasted.

Shooting smaller creatures close-up brings its own set of issues because depth of field decreases the smaller the subject is and the closer you are to it. This is another basic rule of

optical physics. This means that if you have an iguana two feet in front of your lens, you will have less depth of field than if you were shooting a 40-foot long dinosaur foraging a football field away. You might get the iguana's left eye in focus, but the right eye and front of its mouth will be blurry, and so will its dorsal spines. You won't know how much of the creature will end up in focus from foreground to background if you can't stop down and take a look by using your camera's depth of field preview feature. You will essentially be shooting blind. You're guessing, and you'll probably guess wrong. Depth of field preview enables you to see the problem before exposing film, not later over the light table when it's too late.

3. Motor Drive or Power Winder

A motor drive or power winder is not a necessity, but it will prove very helpful. It is not used to shoot bursts of photos like the make-believe photographers do in the movies. A motor drive is used to allow the shooter to maintain visual concentration on subject movement and composition instead of being distracted by the mechanical problems of advancing film and cocking the shutter. It's that simple.

Many of the newer cameras have auto winders built right into the basic camera body. This is convenient, but you'll have to decide for yourself whether it's worth the extra

dinero or not. In my humble but definitely opinionated opinion, it is.

☐ Lens Choices

Lens choice is determined by two things: the depth of your pocket and the type of shooting you're going to do.

As to the financial consideration, buy the best lens you can afford. You won't regret it. Remember that the quality (read: clarity and crispness) of your final image depends primarily on the quality of the glass you shoot through. If you have to compromise, buy a cheaper camera body and a better lens rather than the other way around.

What's your preference: tabletop photography of terraria and aquaria, or shooting pictures of elephants at the local zoo? Each requires lenses with different capabilities. Why pay extra for macro capability in your new lens if the smallest thing you're going to shoot is a four-foot long otter at a distance of ten feet? Contrary to popular opinion, all salesmen are not out to help you get the best tools for the least money. As in any other technological activity, whether it be changing a faucet washer or launching a space shuttle, always choose the right tool for the job that needs doing. In other words, use macro lenses for small creatures or close-up work, and longer glass that sees further when shooting animals in the far

> **Little Known But Very Useful Lens Tricks**
> - Use an extension tube with your telephoto lens to create long range macro capability where none existed before. Experiment to discover workable distances.
> - An extension tube in combination with a long lens will effectively remove all disturbing background elements by thoroughly defocusing them behind your subject.
> - The best loupe you'll ever own for examining slides is your normal 50mm lens, and you already own it. Take it off your camera and hold it to your eye in reversed orientation with the slide positioned where the film originally was for exposure. The result: crisp and clean slide viewing, with no additional investment.

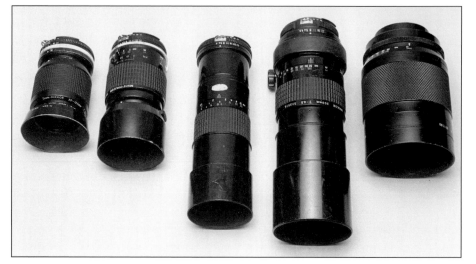

reaches of natural environments at the zoo.

I own lenses that range from 24mm at the short end to 500mm at the long. I also have a doubler to stretch my long reach to 1000mm if circumstances demand it. If you buy a doubler, buy one made by the manufacturer of the lens you're going to use it with. They're designed to work together. Cheap after-market doublers rarely make high quality images.

Two of my lenses, the 105mm and the 200mm, are specifically designed as macro lenses. I paid serious money for them both for their designed-in

A selection of Nikkor lenses used in the photography for this book. Left to right: 35-105mm, 105mm macro, 200mm macro, 300mm, 500mm mirror. Always buy the best glass you can afford, even if you can't afford it. Ain't credit cards great?

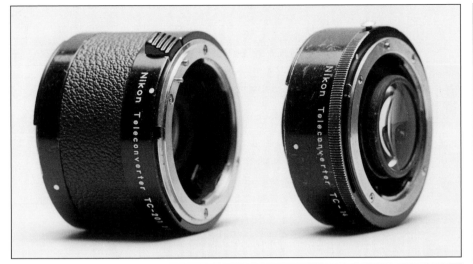

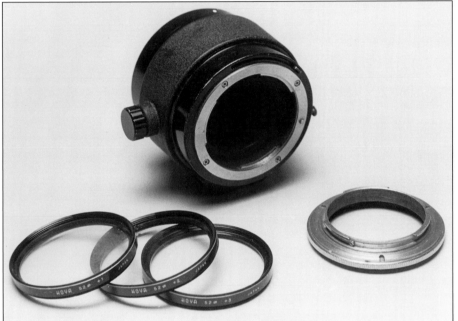

A Simple Way to Determine Exposure Factor for Lens Extension

1. Set your camera up on a tripod facing an evenly-lighted 18% gray surface (use a gray card, cardboard, an old army blanket, or tarpaulin). Fill the frame with the gray surface.

2. Measure the exposure with your in-camera meter.

3. Mount the extension tube or bellows between lens and camera body.

4. Measure the exposure again with your in-camera meter.

5. The difference between the two exposure readings is the amount you must increase exposure when using that much lens extension. Make a label and glue it on the tube or write it directly on the tube with an indelible paint marker.

Top: Doublers (Barlow lenses) come in various strengths, most commonly 2x and 1.4x. They are a relatively cheap way to extend your optical reach. Expensive in another way, a 2x doubler will cost you two stops of light, while a 1.4x only costs one stop.

Center: Three ways to increase magnification and bring you in close to small subject details. Left to right: supplementary +1, +2 and +3 diopter close-up lenses, a meter-coupled extension tube, a reversing ring. Each has its own set of photographic compromises to deal with.

Bottom: A reversing ring allows you to mount a lens in reversed position. The gain: substantial magnification without exposure factor calculation. The losses: limited working distance from lens to subject and no meter coupling.

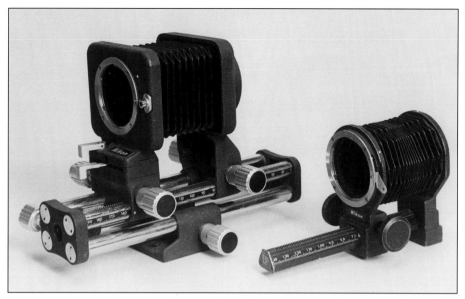

Bellows provide very controllable and measurable magnification. The one on the left is the high-priced version, great for slide copying and studio macro work. To the right is my discontinued but highly-valued and very light weight portable model, perfect for field work.

extra capability and have grown to love them for their flexibility and acuity. They are the simplest, even if most expensive way, to handle close-up photography of smaller creatures.

If you can't afford a decent macro lens, there are cheaper alternatives for close-up work: supplementary close-up lenses, extension tubes or bellows, or a reversing ring. Close-up lenses are +1, +2, +3 diopter supplementary lenses that screw on the front of your existing camera lens to let you get closer to your subjects. Extension tubes or bellows are hollow tubes (no glass) that are inserted between your camera lens and the camera body. A reversing ring allows you to attach the front end of your ordinary lens to the camera body so you shoot through the lens backwards. All of these methods increase magnification substantially.

This isn't the place to go into the intricacies of close-up work. There are plenty of sources dedicated to the subject. Nonetheless, you should be aware of the choices and the advantages and disadvantages of each method.

□ Flash

Flash units come in a variety of configurations and outputs. Regardless of the technicalities, what you want is results based on what the image looks like. Sometimes the subjective result looks different than what the objective calculations would indicate. Always believe what your eye tells you and adjust your technique accordingly. Take notes when you shoot so you can repeat your triumphs and avoid making the same mistakes in the future.

For purposes of succinctness and to avoid covering ground

"Flash units come in a variety of configurations and outputs."

Advantages and Disadvantages

Supplementary Close-up Lenses		Extension Tubes or Bellows		Reversing Ring	
ADVANTAGE	DISADVANTAGE	ADVANTAGE	DISADVANTAGE	ADVANTAGE	DISADVANTAGE
	Glass in light path degrades image.	No glass = clear optical path and crisp imaging.		No additional glass. Image is as good as the lens itself.	
Relatively inexpensive.		Basic tubes can be inexpensive.	High quality (precise or coupled) tubes or bellows can be expensive.		Your camera system's manufacturer sets price.
Available at photo shops everywhere.		Wide after-market availability.		Designed by your camera manufacturer.	Made only by maker of your camera and lens.
No light loss.			Moderate to substantial light loss.	No light loss.	
No exposure factor to calculate.			Calculations required.	No calculations.	
Can be stacked for greater magnification.	More glass = worse image degradation.	Great flexibility & range of magnification.	More extension = more light loss.		Limited magnification range.
In-camera metering works normally.		Stop-down in-camera meter will work for ambient light.		Stop-down in-camera meter will work for ambient light.	
In-camera meter coupling works normally.			In-camera meter coupling disengaged.		In-camera meter coupling disengaged.
Working distance varies with lens combinations.		Extension + medium tele-photo = comfortable working distance.	Greater extension = less working distance.		Severely limited working distance.

you've probably been over, I'm going to assume that you already have a basic understanding of your equipment. This is the place to discuss some theory and give you pointers on what to do and not do, not teach you how to use the specific gear you have and that I've probably never seen before. If you have questions on how to use what you've got, go back to your manufacturer's manual and do some studying. Meanwhile, the rest of us will go forward.

1. Primary Flash Units

The flash unit that is controlled directly from the camera is called the primary flash unit.

The primary flash might be the slide-out/pop-up built-in on a point-and-shoot, a $5 throwaway mini-flash from the used bin at the local camera shop, a TTL flash designed by your camera's manufacturer to work with your particular model camera body, or a highly controllable megabuck studio flash head.

Whatever the unit, it might be used as the main light or it might just be used to fire a slaved secondary unit that acts as the main light. (More on that later in the section on secondary flash units.)

2. Slave (Secondary) Flash Units

A slave(d) flash unit is not triggered directly by the camera. A slave flash unit is attached to a slave sensor which trips the secondary unit when it sees the primary flash go off. Slave sensors are usually located at or near the flash they will trigger, or they might even be built into the heads of some studio units. Using a sensor to trigger a secondary flash unit neatly avoids the problem of cables being strung all over the place hooking everything together.

Slaves come in a variety of shapes and sizes. They can be purchased from most quality photo stores wherever you live. There are even circuit diagrams available in electronics reference books and on the web if you're handy with a soldering iron and want to build one yourself from cheap and commonly available components.

Just hook the slave up to a sync cord the other end of

"Slave sensors are usually located at or near the flash..."

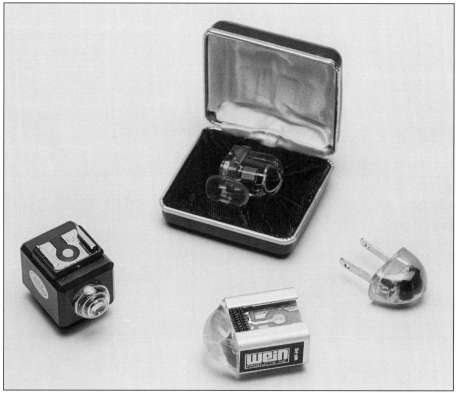

Attach a slave sensor like one of these to a second or third flash for more complex illumination without creating a dangerous and confusing tangle of wires. I've had these so long I forgot the manufacturers except for the Wein. They're widely available at most quality photo shops or mail order houses.

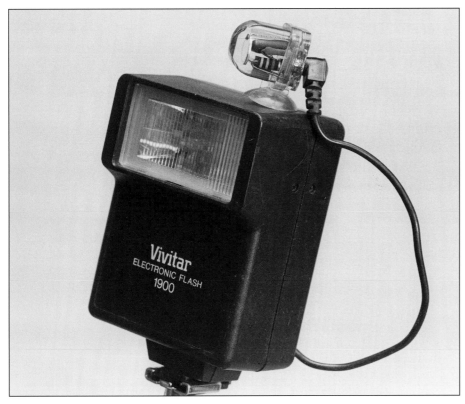

A slave sensor sits atop a small flash unit. When the sensor sees the blast of light from the flash attached to my camera, it fires this slaved unit with no discernable time lag. Ah, the wonders of technology.

which is plugged into the flash unit. You might have to play around a bit to find a proper position from which the sensor can see the primary triggering flash, but once you've got it working, it's great.

Some self-contained studio flash units have slave sensors built right into them. My White Lightning flash heads have them and it's a simple job to set up two or three heads and fire them all off together without tangles of sync cable running off in every direction.

Here's a useful trick. The primary flash unit that triggers the slaved unit doesn't have to be the main light source. Suppose that your main light is inconveniently placed to reach with the sync cord from your

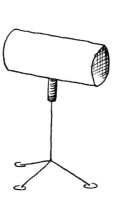

SLAVE SENSOR SET-UP

The slaved light at right is actually the main light source. The fill flash at the camera position is fired by cable from the camera. Its firing triggers the main light.

camera. Rig the main light to a slave sensor and trigger it with the flash that will be throwing the fill light from closer to your camera position. This is how I like to fire my main overhead flash when photographing snakes and other reptiles.

3. Modeling Lights

One of the things that sets professional studio lighting equipment apart from amateur or hobby level gear is the ability to see the lighting effect before exposing film. Studio units have modeling lights that remain on during set-up so the photographer can make adjustments until the light sources are properly balanced. Modeling lights are usually incandescent and are weak enough that the flash completely overpowers them, thus rendering their color temperature unimportant.

Yes, you pay extra for modeling lights, but it's well worth the money. No need to go all the way to high-end lighting gear either. Many of the affordable self-contained units have modeling lights. If you're planning on doing any shooting in a controlled studio environment, check around at the photo shops in your area for a flash rig that falls within your price range. And don't forget the classified ads. There's always someone who's upgrading and selling off used equipment at reasonable prices. Be an opportunist, in a nice way, of course.

A Few Flash Tricks

- Check the shutter speed setting on your camera regularly. In the fury of shooting activity, it's all too easy to bump the shutter speed dial, only to discover later over the light table that you shot everything out of sync. Double, triple, quadruple check; then check again at intervals. (Do the same thing with the ISO setting on your camera or handheld light meter.)
- When shooting close-up with flash, the guide number from the flash's manual is meaningless. Before you get into that situation, do some tests by shooting slides of similarly toned subjects or in comparable situations and develop them to see the results. Take notes during the test shoot and compare the processed slides to the results. What works best? Repeat that. What failed? Don't do it again.
- Just because you have a flash doesn't mean that the color of the light that hits the subject will be correct. Watch out for colored surfaces that will bounce the flash's light back. Red gravel in a fish tank means you might have an overall red color cast to all the fish.

4. The Magic of TTL

The basic flash that many of us started out with was a guessing game or mathematical puzzle. Being totally manual, you had to figure out how much light it was putting out, estimate distances, and work the equation (guide number divided by flash-to-subject distance equals f-stop) to determine proper exposure. Times have changed, and thankfully for the better. Thyristers first, and now TTL flashes, have made life easier for all of us.

When TTL was invented, the photographic paradigm shifted. TTL stands for "Through The Lens" and it refers to the fact that the electronics in the camera talk to the electronics in the flash unit, and between them they determine what the correct flash exposure is, based on the aperture and

"Times have changed, and thankfully for the better."

"... flash photography still isn't totally idiot-proof."

ISO settings. Working together, they then provide only as much light as needed, "quenching" the flash when the job is done. What had been tricky or complex exposure problems became simple.

Of course, flash photography still isn't totally idiot-proof. It gets complicated again when you are working with several flash units, but that's what flash meters are for.

In the fill flash section that follows, I'll give you a few tips on how to use TTL to great advantage.

5. Fill Flash

For many years, the phrase "fill flash" filled me with terror. I didn't understand it, couldn't do it, and thought I was a worthless wannabe because of my lack of fill flash skill. One day, the light in my head went on and I realized just how simple fill flash was. Since then, life has been wonderful; I'm rich, famous, and all the pretty girls notice me. I also now use fill flash to make great pictures.

The Problem: In your otherwise beautifully composed image there is a dark area that needs to be brightened up a bit in an otherwise adequate exposure situation.

The Solution: Throw some additional light, but not too much, into the shadow area to brighten it up a bit. The question is how do you know how much additional light to use.

The Secret: Fill flash is accomplished by measuring the correct exposure for your

An Old Photojournalist's Trick

• In the old days, when there wasn't a whole lot of subtlety in flash lighting, it was easy for a photojournalist's pictures to look as if someone had fired off a grenade in the subject's face. When shooters got onto the idea that flash could be softened, one photojournalist developed a method that was easy to use and extremely portable.

If the flash head is aimed so the light ricochets off a white surface, the quality of light becomes softer and more pleasing to the viewer's eye. You can bounce the flash off a white wall or ceiling, but for fast-and-dirty and highly mobile photojournalism, attach a white card directly to the flash head. With TTL, there aren't even tedious mathematical mental gymnastics. Bounce flash is now yours to command anywhere. (There's no extra charge for this tip.)

• By the way, if you can't find a white card or foam-core board to cut up, there are soft-boxes on the market that will do the same job. The problem is that they cost beaucoup bucks. A white card and some rubber bands costs next to nothing and is easy replaced when it gets worn.

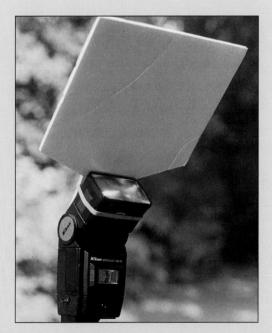

Aiming the flash upwards with a white card deflector attached softens the light falling on your subject. The result is less garish, more pleasing lighting.

ambient natural lighting or main flash source and setting your camera accordingly. Then choose the TTL setting on your flash unit and fire away. It should work. With the base settings for the already existing light, the TTL brain will only throw enough light to brighten rather than to dominate the image. I've used this technique for bringing out detail in barracudas silhouetted against the bright overhead sun in tropical waters, insects at flowers in sunlit meadows, and people in all kinds of situations with lighting that was less than optimum.

One problem that occurs with TTL fill flash is when the TTL brain decides to throw too much light at the subject. Suppose the subject is light colored to start with, and is up against a dark background? Too much fill will wash it out completely. What to do?

First, be sure that your camera is in manual mode. You don't want it thinking for itself just now. Determine the base exposure with your in-camera or handheld meter and set the f-stop and shutter speed controls accordingly. Then goose up the ISO setting by one full stop. (What do I mean? If you don't understand this, better go back and review some of your photographic basics.) An ISO change of one stop is achieved by doubling or halving the ISO. In other words, if the film is 100 ISO, you will trick the TTL brain into thinking the film is twice as sensitive by setting the

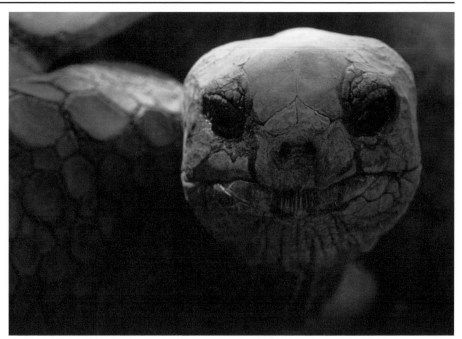

This tortoise was photographed with direct sunlight as the only illumination. Deep shadows under the chin kill the picture.

ISO to 200 on the camera. Now, when the TTL brain fires the flash, it will produce only half the amount of fill. Result? Pleasant subtle fill and no overexposure. Pretty cool, eh? And simple too.

☐ Flash Meters

A flash meter differs from the meter in your camera or a standard handheld light meter in that it can measure the short duration light that a flash puts out. You can even get by without a flash meter at all if you have a standard set-up that you use and have experimented enough with the exposure range within its image area to know what you'll get. You can determine that range by using the Exposure Test Chart in the Resources section at the back of this book. But a flash meter will simplify your life.

I own two flash meters: a Minolta Flash Meter IV and Minolta Spot Meter F. The cur-

"A flash meter differs from the meter in your camera..."

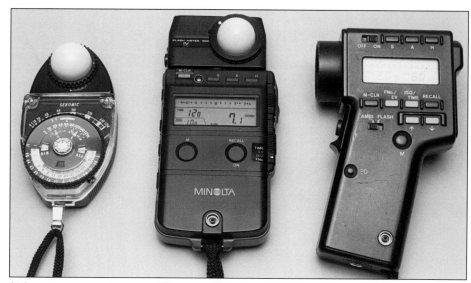

Light meters come in many different configurations, capabilities, sensitivities, and prices. Buy a good meter and treat it carefully. It will serve you well for many years. Left to right: Sekonic Studio Deluxe L-398 incident light meter; Minolta Flash Meter IV for ambient or flash, incident or reflected light; Minolta Spot Meter with one-degree reading spot reading for reflected light. Check your handheld meters against your in-camera meters for consistency and calibration. They should all give similar readings.

"I bought them back when I had lots of money and no self-restraint."

rent generation of the first is now the Minolta Flash Meter V which sells new for about $550; a used Flash Meter IV can be had for about $350-400. The second is still being made and sells for about $375. I bought them back when I had lots of money and no self-restraint. Do you need to invest that much in a flash meter? Not necessarily. There are perfectly adequate flash meters that sell in the range of $80-200. But I do recommend that you buy some kind of flash or combination meter if you're planning to do any serious work under controlled studio conditions.

☐ Camera Supports

When doing tabletop photography of terrariums or aquariums, I rarely use a tripod. I find that I like being able to move around more spontaneously, to change angles and framing, and to respond quickly to small animals in motion.

I pay for not supporting the camera on a stand of some kind, though. The concentration of shooting is extremely wearing on me and I find myself in a sweat after about 10-15 minutes of intense shooting. If you have the same response, just take frequent breaks. You'll make it.

1. Tripods

For shooting in zoos and large commercial aquariums though, particularly with long, heavy telephoto lenses, a tripod or monopod is a necessity. The sheer weight of the equipment will wear you out physically, and your concentration on composition and subjects in motion will suffer.

The trick is to find a workable compromise between solid support, carrying weight, and price. A good compromise is the

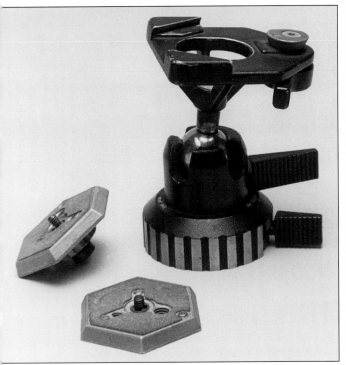

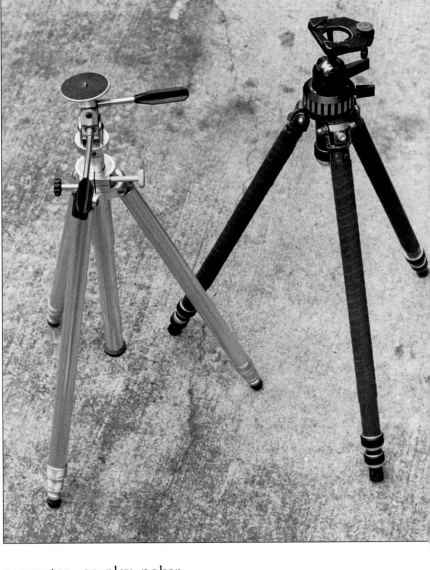

Above: This Bogen Model 168 tripod head is reasonably priced and provides quick release ease for fast-changing action situations.

Right: Two tripods that provide solidity of support in reasonable compromise with weight and price. Left to right: Tiltall Model #4602 from Leitz, Gitzo Studex 320 with a Bogen 168 head. The Tiltall stands to five feet (without extending the center post); the Gitzo drops to the ground or rises to a rock-solid five feet and five inches. Don't buy a "toy" tripod for $19.95. It's a waste of money. It won't give you the stability a good solid tripod is supposed to provide.

Gitzo Studex 230 with a Bogen Model 168 quick release head.

Remember that the purpose of a tripod is to provide solid support. That's the reason a tripod has three legs. If you crank up the center column, you no longer have a tripod; you have an unstable monopod sticking up from a three-legged base. Vibration and camera shake will increase noticeably. Don't do it.

☐ Shooting Stages

If you've got a table you're not using to eat on, support your computer, or play poker, use it to photograph small animals. If you don't have a table, you've got to fabricate something.

As a shooting stage, I've used everything from a kitchen table to a wrought iron aquarium stand (what it was designed for, after all), but the best has been saw horses straddled by planks. I prefer this trestle arrangement because it can be switched around easily to fit whatever the need of the moment is. I don't have to

"I prefer this trestle arrangement..."

worry about spilled liquids or stapling background paper to it either, and that saves on domestic antagonisms.

Legs for a trestle shooting stage can be either shorter or longer than for a carpenter's saw horse. This will enable you to shoot down on subjects that need to be seen from above or to work at a comfortable height without bending over when shooting subjects that need to be seen head on. It's a very flexible system.

Fabricated metal saw horse brackets can be purchased for a few dollars at any home improvement supply store. Just cut some 2x4 legs, a couple of

Right: A shooting stand is simply a platform to work on at a convenient height. It can be temporary and portable or permanent, low or high, expensive or cheap. Saw horses make very flexible arrangements. Buy ready-made brackets at any home improvement store. Here's a set-up to shoot baby turtles.

Below: Why buy a tripod at all if you're going to do this? Just think of all the money you would have saved by purchasing a monopod in the first place. If you crank a tripod's center post up to full extension, you no longer have a stable photographic platform. What you have is an unstable monopod with three legs somewhere way down at the bottom because the photographer is too lazy to extend the tripod's three legs. Don't do it.

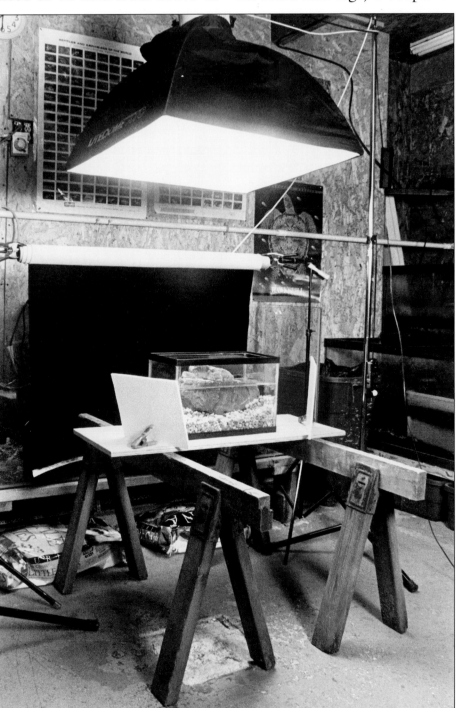

crosspieces, and put them together. They have to be stabilized, but don't use nails. Instead, use those pointy black sheet rock screws. To hold everything together, rub the screw threads across a dry cake of soap so they'll penetrate the wood without binding and zip them into the 2x4s through the bracket's guide holes with a hand drill and Phillips head bit. It's easy enough to take the saw horses apart for storage or if the length of legs or cross members have to be changed. If you buy two sets of brackets, you can have a short stage and a taller one ready to go in a few minutes. Just store them out of the way until you need them for photography or any other home project.

☐ Tape Measure and Paper

If you have trouble remembering your set-ups, measure the subject to flash distances horizontally and vertically, and draw floorplans of the set-ups. These don't have to be highly detailed and precise engineering drawings. Just make them clear enough to serve as a reminder.

☐ The Basic Location Shooting Kit

There's a time coming when, after all your study, preparation, and home shooting, you're going to get a new and different type of phone call. "Hi, I've had an Savannah Lizard for three years now and I'd like a nice photo of him for my office at work. You were rec-

ommended as a reptile photographer. When can you come over to take his picture?" Now what?

It's time to make a house call. What should you bring? How much time are you going to need? Is the wiring and amperage adequate for your lights? What kind of film is right for this job? How much room is there to work in? These are the kinds of things you've got to start thinking about right away.

"It's time to make a house call. What should you bring?"

Basic Location Shooting Kit

- Camera – One or more bodies that work. Don't forget motor drives or power winders and fresh batteries to power them.
- Lenses – How close are your subjects going to be? Is this a zoo shoot or tabletop work? Remember Mr. Natural's admonition from the 1960s: always use the right tool for the job.
- Light meter – Is the meter in the camera enough? Perhaps not for flash work. If flash work is in your future, start thinking about investing in a decent (accurate, reliable, and reasonably priced) flash meter.
- Tripod – Solid but not totally industrial. Will you be moving around from one zoo compound to another, or working in tight quarters with no need for mobility? Buy accordingly.
- Film – Once again, use what's appropriate. Are you shooting for possible magazine publication? You want to use color transparency film for that, and as slow a film as possible to reduce grain problems. How about the guy who wants a shot of his pet iguana for his office wall? Shooting color print film might be best for him. (You might want to shoot some slides in a second camera body for yourself too.)
- Light – Depending on where you're shooting, you might need nothing or everything. Outdoors at the zoo on a midsummer's day you might need nothing at all or just a simple flash to provide a little fill. Inside on a tabletop you might require one or more flash units, light stands, gobos, reflectors, and whatever else it takes.
- Miscellaneous – Light stands, cables (and backups), slave triggers, reflectors, a roll of black velvet for background, aquariums and materials to decorate them appropriately, gaffer's tape, cases to carry everything conveniently and safely.

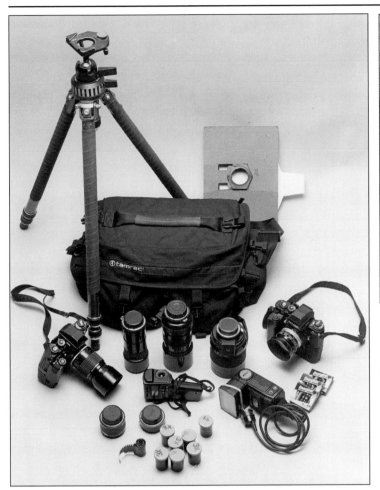

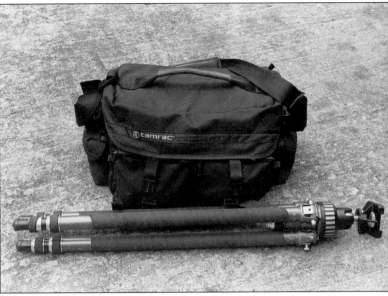

Left: My basic kit for shooting on location. It's compact, yet contains almost everything I need to make the needed shots.

Above: My basic location shooting kit packed and ready to hit the road.

"What are you going to use for light?"

And of course, what should be in a basic location shooting kit anyway? Well, let's be obvious and say camera, lenses, tripod, film, and a bunch of other stuff. What else?

What are you going to use for light? Existing natural light? Flash? Photofloods? How are you going to support them? That probably means light stands. And how about background material? What's this guy already got in place? Are you going to shoot the creature in its home tank, or are you going to take it out and put it somewhere more photogenic and controllable? Might need background stands too. Lots of questions, eh?

☐ A Word About Digital Cameras

We're getting there, but to my mind we're not quite there yet. Digital cameras are starting to look like a better bet than they did several years ago, but I'm still not buying one myself. My problem is the substantial investment I've made over the years in high quality Nikon glass. I want to be able to use those lenses with the digital camera body that I finally buy. Right now, I won't plunk down $6,000 for the body that will do it. Maybe in another couple of years.

However, a digital camera might be just the thing for you. There are affordable cameras

now with zoom lenses equivalent to 35mm-120mm and reasonable resolution. That might be enough for you. If so, watch for price drops, special sales, maybe even for a previous model closeout when the new one hits the market. The time is fast approaching for us all to be shooting digital at least part of the time.

The undeniable fact is that photography is going to be digital in the future. The publishing industry has been moving there for years already, and many commercial printers have the ability to go directly from computer to plate right now. Even before they had that capability, images were routinely scanned and manipulated in the computer before being output as separations or large negatives. PDF files are all the rage now and are making the printers' life even more high tech.

Are we "old silver guys" going to be able to continue shooting physical, silver-based emulsion film? The answer for the foreseeable future is an unqualified "yes." I believe there will always be a supply of film of different emulsions for us "real" photographers. There are lots of pure artists who continue to work in many other outdated media, too. High quality scans will continue to have a better "film" look than original digital images. We're safe for our lifetimes.

It's important to also state that just as the wide availability of page layout software didn't make competent layout artists of everyone, so mass sales of auto-everything digital cameras will not transform everyone into Ansel Adams. There will always be a strong need for people who understand lighting, composition for content, subject manipulation, darkroom technique, and photographic ethics. There will continue to be a need for the educated professional or advanced amateur photographer. Be reassured.

"... photography is going to be digital in the future."

6
FINDING CAPTIVE SUBJECTS AND SHOOTING LOCATIONS

☐ Where Are They?

Captive animals are all around you. All you've got to do is find them. How is it done? Simple. It's been said that anything or anyone you need is only three or four links down a chain of people who know other people. Try it and see what you can come up with. If you never ask, you'll never find. Start asking around. Ask relatives, friends, and total strangers. Who cares if they think you're nuts? You're on the trail of your greatest photograph.

For smaller animals, a great place to start is your neighborhood pet store. If I'm in a new area, I make it a point to go around and check out the local pet shops. One will specialize in salt water aquarium fish. Another will be a snake and reptile house. A third will handle exotic birds. A fourth will have posters up advertising an upcoming dog breeders' gathering. Don't forget veterinarians either. They know their clients

and the animals they keep. All are legitimate avenues to the captive animal pictures you want.

We're a remarkable species ourselves, you know. We specialize in different subjects, and then we gather together to service those specialty interests. Connect with the group in your area that is into the animals you want. They'll want the same pictures that you want. Trade them pictures for access.

For larger animals, a zoo is the logical first stop. If you don't have a zoo in your home town and you live in the continental USA, there's probably a great zoo within 200 miles. Drive over and check it out. Meet the people and talk about pictures. Zoos are always in need of good pictures of their charges. Once again, trade your successful pictures for access to the facility.

Zoos are great places because they have animal species from far, far away and local

"Captive animals are all around you."

species that are difficult to find in the wild. They also have biologists and research libraries. A friend at a zoo is a contact point for all kinds of information and access to unique animal events such as births and surgeries.

If you don't have a zoo handy, I'll bet there's a nature center. These often have live native animals, and the folks who work there are usually fountains of local lore as well as basic animal facts. They are also always looking for good pictures for their brochures, fund raising events, and lectures, so here are other great opportunities to trade photos for access. You might even be able to sell prints in their gift shop (with a percentage going to the nature center, of course).

☐ Subject Locations by Type of Facility

Individuals – Relatives, friends, strangers, animal enthusiasts, staff at various animal or environmentally oriented institutions. People who keep animals are everywhere. You'll be surprised what turns up once you start asking around.

Zoos – The best places for exotics in well-landscaped, well-kept environments. Great sources of information too.

Safari Parks – Shoot exotics right in your own state. There's

Don't despair if you need a shot of a seemingly impossible-to-find subject. This eastern diamondback rattlesnake skull was found after only two phone calls, one to a herptile pet shop to get the second number, followed by a call to the man who had the mounted skull. The shop owner even called ahead to establish my bona fides. I traded slides of the skull for access to shoot it.

probably one of these controversial facilities within a few hours driving.

Nature Centers – Local nature centers are great places to see and photograph native species. These people are usually very friendly and easy to deal

Don't neglect barnyard animals. This sheep in a dark barn makes a great portrait that captures the true "sheepness" of the animal.

with, especially for a small donation or some free pictures. A good place to find allies.

Aquariums (Commercial and Home) – There are some beautiful commercial facilities around the USA and more being built all the time. And don't forget the carefully maintained marine aquarium that Uncle Ernie has in his home or office.

Pet Shops – Find one that specializes in the type of creatures you're after. You'll learn lots of interesting things, and make friends in the process too.

Wild Animal Repair Facilities – Great places to photograph raptors, raccoons, opossums and other wildlife that might have been brought in and can't survive if released back to the wild. Careful framing can avoid the damaged parts and produce incredible portraits.

Veterinary or Research Institutions – Vets get all kinds of strange requests for help. There might be one in your area who handles reptiles, turtles, or exotic mammals. They'll know the local breeders and hobbyists, too.

Schools and Universities – Your local high school biology teacher might be a breeder of some exotic critters. Call and find out. University biology departments are always in need of good pictures and there's usually an assistant professor or graduate student available to help with taxonomic and zoological information. Might even

find a collaborator for a thesis or book. Universities have great libraries too.

Farms – Farmers keep horses, cows, llamas, goats, sheep, emus, ostriches, pheasant, quail, ducks, geese, other domestic fowl, and of course, honeybees. All make great subjects. Local farmers probably also have a guy they call to capture snapping turtles out of their ponds or to catch and remove their copperheads. Get his name and number and give him a call, too.

Fish Hatcheries – I hadn't thought of this but was explaining the book to someone in conversation and they came up with it. An interesting idea. These could be either federal, state, or private. From my experience, private facilities might be easier to deal with. Less red tape.

☐ **Subject Locations by Type of Animal**

Mammals – Zoos, nature centers, personal pets, breeders, farmers; all are great contacts for mammal shots. I once ran across a large corporate retreat center with its own human-acclimated whitetail deer herd. Don't forget everyday pets like dogs and cats. Many people keep ferrets, too. Do set-ups with your children's gerbils to climb the technical learning curve.

Reptiles and Amphibians – Reptiles are the current pet craze. Try commercial aquariums, pet shops, breeders, wholesalers, and hobbyists. I

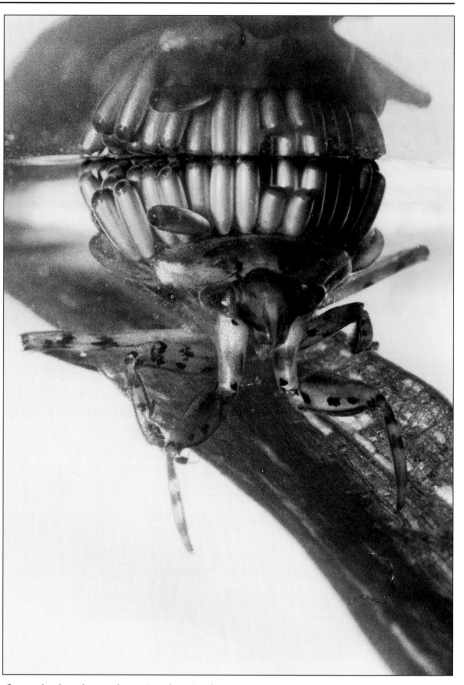

Belastoma water bug male with eggs on its back. Shot by window light in a 10-gallon tank kept for aquatic insects. This is what I did for recreation while in law school.

found the best bet is the individual herp enthusiast who keeps several species for personal enjoyment. They are always enthusiastic about pictures of their scaled pets.

Birds – Zoos, nature centers, raptor repair facilities, farmers, bird breeders, and pet shops are all great contacts for bird photographs. I found that

raptor repair centers are the most thrilling because of the kind of shots you can get of hawks, eagles, and sometimes even kestrels. You can get right up close to birds that are totally unapproachable in the wild. With careful framing, backgrounds can be minimized and the damage that brought the bird to the center can also be excluded. Great raptor head shots await the intrepid shooter.

Fish – Try individuals, commercial aquariums, pet shops specializing in marine and freshwater fish, aquarium clubs. There are lots of people keeping all kinds of things, probably right down the street from you.

They don't advertise, but they might be cooperative to someone who's enthusiastic about a hobby they're proud of.

Insects – Catch them yourself. There still isn't any great grass roots movement supporting insects' rights, though there may well be by the time this book is in distribution. One of my favorite subjects is honeybees. Find a local beekeeper and make sure he/she calls you when a hive is about to be serviced or robbed. You'll need special clothing for this. Honeybees are usually pretty reasonable to deal with but don't take the chance if you're allergic to stings.

Water scavenger beetle working on a dead freshwater shrimp. Shot by window light.

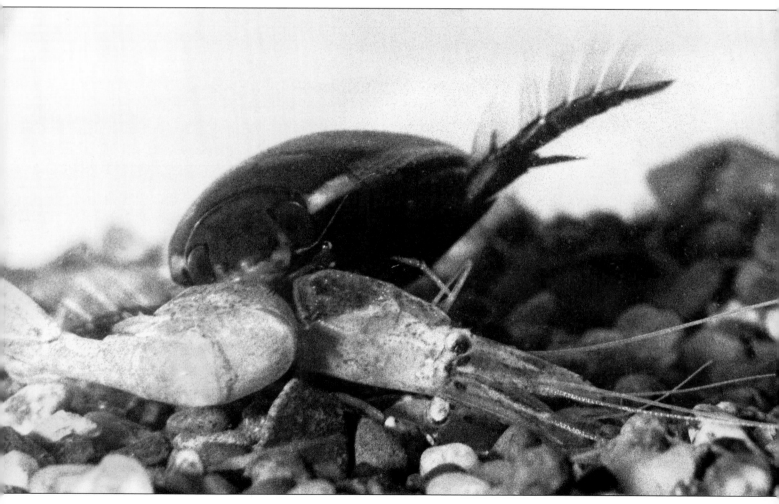

7
SPECIAL PROBLEMS

Most everything we try to accomplish in this life must overcome obstacles to succeed. Why should captive animal photography be any different?

Photography in general is vexing simply due to problems of light and shadow, exposure, chemical inconsistencies, and equipment failure. If you're shooting people, you have additional problems like punctuality, costume, and acne. Photographing on location adds complexities of weather, transportation, accommodation, adequate work space, forgetting the 25-cent gadget that might hold the entire production together, not enough gaffer's tape, wrong type of electrical plugs, an unexpected short in the "there's-only-of-these-in-the-equipment-box" cable, no place to buy fresh or specialized film, and no quality processing lab within 250 miles, among other things.

Shooting animals changes the equation again, and never in the photographer's favor. You now have problems with finding the animals in the first place, animal control once they're found, animal moods, animal well-being, photographic shyness, fear of humans, and subjects that like to hide behind objects or are only nocturnal.

There are things we can do to minimize the problems, but we have to plan ahead, something that we humans are notoriously inept at. Try anyway. Act with your end goals in mind, but think pessimistically. Plan for the worst possible situation and you'll probably have most everything covered. And although it's a logistical nightmare, bring everything you have with you to the shoot.

☐ Dangers to Animals and How to Avoid Them

Animals stress easily, and that should be minimized as much as possible during photography. Preventing them from going where they want to go or

"There are things we can do to minimize the problems..."

overheating them under incandescent lights are two of the biggest dangers.

The problem of limiting an animal's traveling range for photographic purposes can be considered in two different contexts: large creatures and small.

Larger animals will probably be shot in zoos or safari parks, and thus, the problem is already solved. Zoos will already have the animals behind enclosures. The quality of these enclosures varies all over the scale, from the 3x4x4-foot jaguar cage I saw in Panama to fully natural environments with plenty of roaming room. In any case, the problem is out of your hands. Feel no guilt.

In safari parks, you will probably be in the rolling enclosure of your automobile, in effect, a mobile blind. The problem for you will be that of shooting through your auto's window glass or through windows open just enough to get the front end of your lens through.

In all such situations, just as in the wild, let caution be your guide. Don't expose yourself to unnecessary danger. Keep in mind that, although an animal is a captive and may have been so for years, it is still an animal with all its primordial instincts and tendencies still intact. Don't become an unwitting victim just to get a better shot. It isn't worth it either to you or to the animal that might be destroyed as a result of what it felt was a provoked attack.

"Don't become an unwitting victim..."

Smaller animals (small mammals, herptiles, fish, even insects) shot in situations using small enclosures are going to be stressed by suddenly being confined in a new environment and their inability to get away from the big, bad, predator camera eye. The best way to handle this is to construct your set-up, and when it meets your aesthetic approval and photographic requirements, place the animal in it and stand back.

Give the creature enough time to acclimatize to its new surroundings. Don't be in a rush. Allow as much time as it takes. With any luck, the creature's initial fear will be replaced with curiosity about its new home and finally acceptance. That's the time to begin photographing, not before. Animals placed in enclosures the day before photography or given a full day and night to acclimatize will do just fine. In the end, everyone, animals and humans, will be pleased with the results.

Overheating animals during photography is more likely to occur with smaller creatures that are shot in more traditional studio set-ups. Lights that remain on for extended periods at full photographic intensity are the problem. Try not to use incandescent lights at all. If that's your only choice, keep the lights on for the minimum time possible, and watch your animal subject carefully for signs of heat stress.

Using flash will minimize the problem because of the

short light blasts. The modeling lights in studio flash units are not as much of a problem as photographic incandescents because of their low intensity, but be sure to monitor the animal nonetheless.

You'll sometimes read the tip of refrigerating small animals like herptiles and insects for a short time to slow them down enough to photograph. Don't do it. I don't mean to get "spiritual" or anything, but I'm always reminded of a cartoon I saw years ago. It showed a busy big city corner full of people, all of whom were reaching up into the air to grab a $100 bill that was hanging there on a big fishhook attached to a line coming down out of the sky. Just think about how you would feel if someone threw you into a refrigerator to slow you down.

We're all part of the same Great Life Force, people. Try to keep that perspective, will you?

☐ Dangers to Photographers

In the wild you only have to worry about sunstroke, hypothermia, poison ivy, fire ants, hordes of mosquitoes and deer flies, quicksand, hostile locals, poisonous snakes, and getting lost, among other things. In a captive animal shooting situation, working within limited physical surroundings, the dangers are more prosaic but nonetheless equally dangerous and the effects perhaps longer lasting.

The most common cause of household injuries is falls. In a

For your own and other people's safety, tape cables down to floor or rug with gaffer's or duct tape. It only takes a few seconds and can prevent nasty accidents caused by tangled feet.

controlled photographic situation, tripping over cables, being hit by falling light stands, and banging your head on lights or background supports are all common mishaps.

Cables shouldn't be allowed to snake around in every direction. They don't get that way by themselves either; they have help. Try to give your set-up some basic order. It makes it easier to trace problems as well as preventing accidents.

Wherever the public will be crossing over your cables, make the danger zone as small as possible by laying the cables out in an organized way, and taping them down with 3-inch wide gaffer's tape. That's how the pros do it.

As for falling light stands or banging your head, just keep your eyes open and your wits about you. Don't let the intensity of a shooting session cause a total lapse from your physical reality. Watch where you put your feet and be aware of where

your apparatus is. It's not too hard to do. And don't get upset if your shooting partner is always saying, "Watch out for that (whatever)." He/she is only doing what you should be doing for them too. You're there to cover one another. That's teamwork.

In addition, do I have to mention not using frayed electrical cords with exposed wiring, and warn you to lift with your legs and not your back? Basic common sense goes a long way in preventing injuries.

A gallon of tap water weighs about eight pounds and can be used to stabilize top-heavy light or background stands. Use two in high traffic areas where the possibility of an accident is higher or greater stability is required.

☐ Inability to Meter Subjects

You're standing outside the zoo compound's containment fence but the troop of baboons is on an island more than 75 yards from you. How are you going to get an exposure reading on them? It's pretty easy, and there are several methods for you to choose from.

The first method is to use the in-camera meter and the telephoto lens you're going to use to make the shot. In many modern cameras, you have a selection of different measuring modes. Which you use depends on the final result you want. For freezing the action, use shutter speed mode and set a fast shutter speed. Of course, the faster the shutter speed, the less depth of field you'll have because the aperture will have to be more open.

Conversely, if you meter in aperture mode because you want more depth of field, you might loose the ability to stop the action. It's the same old photographic compromise, but it's working in the opposite direction. If you don't understand how this works, you need to bone up on basic photographic theory and practice.

Your in-camera meter probably has an averaging function which will see the entire frame and give you a general light reading. Some cameras also have the ability to weight the reading by emphasizing selected areas of the frame more than other areas. Center-weighted metering is an example. If you

paid extra for this capability and have it, read your camera manual and learn to use it.

A second way to get a spot reading on those far away baboons is to measure the light through a longer lens than you plan to shoot through. If you have two bodies, keep your longest lens mounted on one to meter through while exposing film in the second body. Be sure the ISO settings on both cameras match or that there is an easy mental conversion such as $^1/_2$ or two times the measured exposure by using ISOs that are double or half of the other.

A third way is to meter a gray card in light that is the same as the light falling on the subject. Buy an 18% reflectance gray card, cut a pocket-sized square from it, and drop it into your pocket. Pull it out when faced with a metering quandary. If the subject is in sunlight,

meter the card in sunlight. If the subject is in shade, shade the card with your body and meter it. If the subject is in dappled shade, put the card under dappling shade and meter away. Distance is no longer a factor. This stuff is really pretty easy, isn't it?

By the way, the gray top of the plastic container that many Kodak 35mm films come in is 18% gray. You probably already have a cassette container even if you don't want to buy a gray card and cut it up. Measure exposure from that.

A fourth way is to meter the palm of your hand. This takes some pre-planning and experimenting by doing some exposure tests at home before going out to shoot. We used to use this method when shooting underwater where metering was always a problem. The palm of the average Caucasian hand is

Take a reflected meter reading off a pocket gray card when your subject is at too great a distance to meter directly or your incident meter is in the shop. A pro shooter friend of mine used to laugh when I described this technique until he saw me use it in a tricky metering situation. Now he carries one himself.

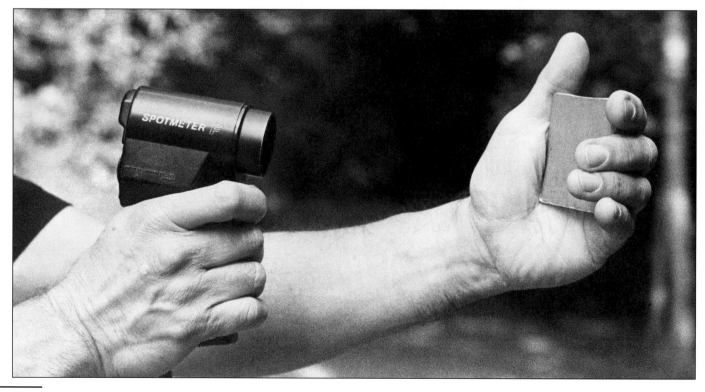

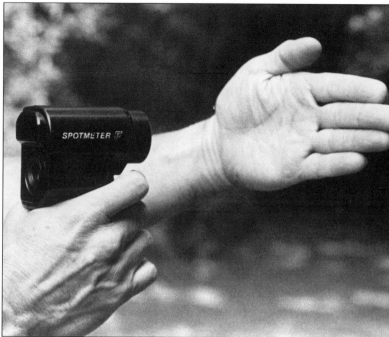

Top, Left: The palm of your hand is a great constant metering reference, and you always have it with you. Just know the difference in reflectance between it and an 18% gray card.

Top, Right: How close are the tonal values in your palm and the 18% gray card? Measure it and know for sure. Since you've always got your palm with you, exposure will henceforth be easy.

Left: If reflectance metering vexes you, get an incident meter that measures the light falling on subjects instead of light reflecting from them. I hate to sound like an advertisement, but this Sekonic Studio Deluxe L-398 meter always was and continues to be one of the best buys on the market in terms of accuracy, flexibility, durability, and price.

about one stop more reflective than an 18% gray card, but different palms vary all over the place. Your measurement will be specific for you. It will be exact and reliable, as long as your hands are clean. If your new suntan includes your palms, recalibrate yourself by doing another set of exposure tests.

The difference in reflectance between the palm of my hand and an 18% gray card is one full stop. My hand is brighter. One stop is equal to one f-stop click on the lens, the next full shutter speed up or down, or half or twice the ISO. If I meter off a gray card, I'll use that exposure reading directly, making the usual slight adjustments for dark or light subjects. If I meter off my palm, the meter will think there's one full stop more light, so I'll have to open up one full stop. It's that simple.

To discover the reflectance of your palm, meter it. Then meter an 18% gray card. What is the difference in f-stops? That's your factor. Your palm is usually lighter, so the meter will think there's more light available. Adjust your exposure accordingly. No problem.

So far, all these methods have used metering methods that measure reflected light.

Life is even simpler if you have an incident light meter. Exactly like using the pocket gray card, meter in light that is the same as the light falling on your subject. Once again, no problem.

☐ Shooting Through Obstacles

Something is between you and your subject. It might be a fence at the zoo, a drooping tree limb, or perhaps it's a sheet of glass or acrylic at a commercial aquarium. It might just be the heads of the proletariat massed in front of you. Except for glass, none of these obstacles are optically transparent. Even good glass might be spotted by the animals inside, condensation, or children's sticky candy-coated fingers outside. What are you going to do?

The simplest way to deal with an obstacle is to avoid it. If you can solve the problem by moving a couple of feet to the right or left, do it. That might be enough. The challenge then might only be to compose the image a little differently. Try it; it's the simplest solution.

1. Fences

What about that fence that's blocking your photographic view? Well, depending on whether it's made of wood or metal and how close you can get to it, might not be a problem at all.

Wooden fences are of two types: a panel fence that you can't see through at all, or a more decorative fence with lots of room between its rails for you

to shoot through. The first type is impossible. You have to get around it or inside it.

The second type, the more "open weave" wooden fence, particularly if nicely weathered, is less offensive than chain link. You might even be able to use them to photographic advantage as compositional elements.

Two wooden rail fences blocked access for a shot of the Aldabra tortoises at Zoo Atlanta. How was I supposed to get a decent shot?

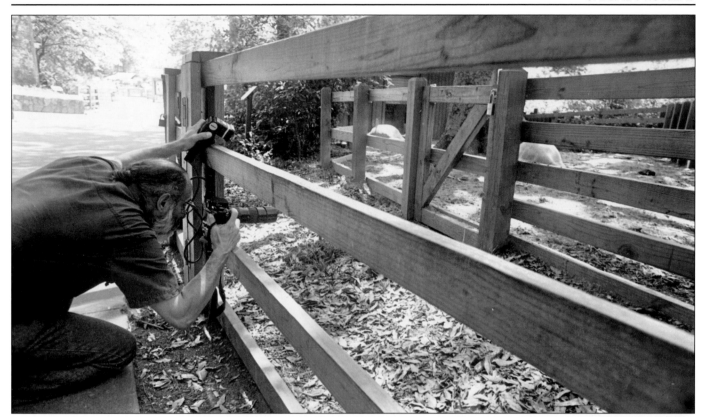

Top: Leave your dignity at home when going out to photograph. Getting down to the animal's eye level and shooting between the rails worked out fine. It got a lot of laughs from the rubes, but I got my shot. Notice the flash held off-camera on a three-foot cable.

Right: Chain link fences are a never-ending challenge. If you can get this close though, placing the front of your lens right up against the fence and sighting through one of the open links, the fence will magically disappear from your picture. Of course, there's still the fence out at the rear of the enclosure to worry about.

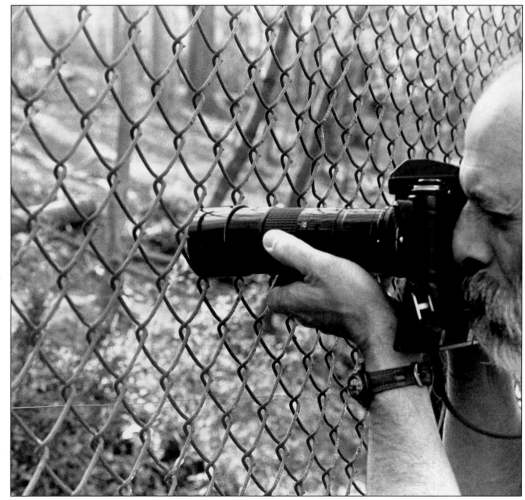

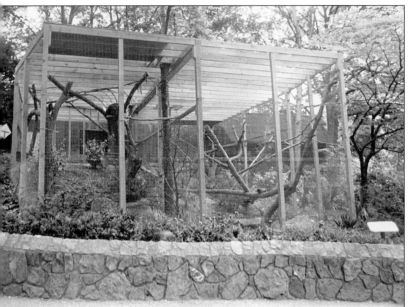

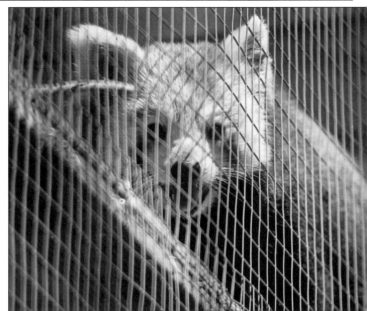

Opposite, Top, Left: Zoo Atlanta's red panda enclosure presents a seemingly insurmountable photographic challenge. Most obvious is the metal fencing above, behind and over the panda's territory. Then there's the low wall that prevents you from getting close enough to the fence to eliminate it with the depth of field trick.

Opposite, Top, Right: Metal fencing can be a disaster to shoot through. You could waste a lot of film before getting a decent shot of the red panda.

Opposite, Bottom: Successful red panda shot. Look for the right angle to minimize glare, and the correct depth of field to remove disturbing fence elements in front of and behind the subject creature.

Compasses aren't just for finding your way out of the woods. They're handy for figuring out where the sun will be at different times of day so you can plan your shooting angles and itinerary ahead of time. Add a compass to your camera bag permanently. The wristband compass is with me all the time and comes in handy more than you might initially think.

If not, look for holes to shoot through, or ways to shoot over or around them.

If the fence is of silvery metal and the sun is bright, you might not be able to work the problem out using the depth of field trick. The sun's glinting reflection off the fence may be a fatal flaw in the image. Try changing your angle of attack. Move a few feet left or right. Does that help? Take a more oblique angle to the fence. How does it look now? Maybe you need to go around the corner of the compound and shoot at a dramatically different angle.

This is a good point at which to recommend that you buy a decent compass and drop it into your camera bag as a permanent addition to your kit. It comes in handy for planning your attack. Check the lay of an animal's containment against the travel of the sun. You can then figure out what time of day the glare will be less of a problem. Just come back then. A hunter's watchband compass is really all you need I use mine all the time. And it's a great conversation piece, too.

If the sun's reflection off the fence continues to be a problem, come back on an overcast day. It'll be a bit darker, so you'll have to shoot at a more open aperture. Besides reducing the reflection glare with the overcast, the open aperture will reduce your depth of field and it might be the answer to final elimination of the fence from the photo. Color saturation will be better too, and there won't be any deep shadows to fill either.

Not too many photographers want to carry a step ladder with them when they go out to shoot. There's quite enough to lug around without adding more metal. But it might not be as ridiculous as it sounds. A three-step aluminum kitchen ladder might just get you that otherwise unattainable shot.

Another alternative is to stand on a solid camera case. I have an aluminum-covered ply-

wood case that easily supports me. It's helped me out by providing that last critical 12 inches of height numerous times over the years.

If you're thinking about that extra weight and how to move it around, you might also think about getting one of those folding airline luggage carts. Buy one that's substantial enough to carry the weight of cameras, lenses, step ladder, etc. It's perfect for zoo shooting where you'll be on paved walks. I use a regular medium-duty industrial hand truck. You might have to ask permission before bringing it in though. Tell them it's the battery pack for your pacemaker.

Glare aside, the other big fence problem is that you can't get rid of it. It's either an inescapable foreground element or in the background behind the subject animal. What can you do about this In big enclosures, it's usually pretty easy to deal with by careful composition. The smaller the enclosure, the more your depth of field becomes fatal to the shot.

The most straight-forward way to remove a background fence is through creative composition. Frame the animal so that there is vegetation, rock, or other animals blocking the view of the fence. A longer lens will help by reducing the area of problem. Nothing more needs to be said on this. The solution is in the situation and you'll have to adapt to it in each individual case. Most of the time,

composition is the reasonable approach.

Foreground fencing is another matter. If you can place the front of your lens right up against the fence, most of the time it will disappear, photographically, that is. Most zoos I've seen have a two or three stage fence arrangement though: an inner fence (usually electric) to keep the animals contained, and an outer fence to keep the rubes (that's us) away from danger. Sometimes there's a deep wet or dry moat too. The problem is that you'll never get close enough to the inner fence to eliminate it by proximity to the lens.

It's time for a warning: don't try jumping fences to get a better picture. There are several reasons for this. The first is that you'll encourage chaos. The kids will all imitate you and

A small hand cart is very helpful for transporting heavy equipment around a zoo all day. When you're young and full of juice, equipment weight is merely inconvenient. As you age, however gracefully, wheels become more and more indispensable. Save your back and your energy for photography.

so will supposedly smarter adults. The rules are there to protect you, which leads us to the second reason: animals are dangerous. Even zoo animals that are used to humans can be pushed too far. They might just be having a bad day; animals have moods too, you know. And you are a stranger to them. The fences are strategically placed to protect you. A third reason is that animals can be stressed to neurotic levels pretty easily. They are already prisoners, so give them a break. Think how you would feel.

The slickest purely photographic way to avoid a fence is by manipulating your depth of field. Remember the depth of field preview button that you paid extra for? Now is the time to use it to salvage the situation. Frame the shot you want and stop down (push the depth of field preview button) to check the operative depth of field. Does the fence come into focus? Here's a simple solution.

A basic principle of photography is that the more open the taking aperture is, the less depth of field you have. How open can you shoot this shot? Find the most limited depth of field you can work with and move that depth of field range further away from you. Holding the depth of field preview button down, adjust your point of focus out toward infinity. The subject

> "... animals have moods too, you know."

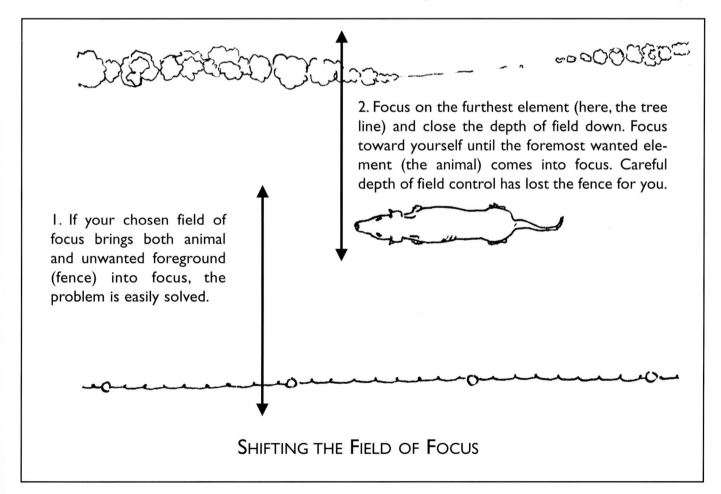

2. Focus on the furthest element (here, the tree line) and close the depth of field down. Focus toward yourself until the foremost wanted element (the animal) comes into focus. Careful depth of field control has lost the fence for you.

1. If your chosen field of focus brings both animal and unwanted foreground (fence) into focus, the problem is easily solved.

Shifting the Field of Focus

should still be in focus, but you might be able to force the foreground fence to disappear. Shutter speed will have to be faster too, but that might work out even better. Problem solved! This is the concept of hyperfocal distance in action, used practically and without vexing and unnecessary mathematical calculations.

One last thing. Recognize that sometimes the conditions are such that you're simply not going to get the shot you want. The best solution might be to visit another zoo. Plan another photographic adventure.

2. Glass and Acrylic

The biggest problems with glass and acrylic are cleanliness, distortion, and reflections.

Cleanliness is vital to clear photography. The photograph can't be any clearer than the medium it's shot through. If you are photographing your own aquarium or terrarium, cleanliness is your own responsibility. Elsewhere it might be an insurmountable problem.

Pet shops interested in keeping up a good image will take good care of their tanks and containments. Their sales figures depend on how their displays look, so they have the incentive. They probably clean their tanks on a regular schedule. Find out when cleaning day is and plan to shoot after all the particles have settled. If they clean daily, plan accordingly.

Large commercial aquariums present a different problem altogether. I've been at the Tennessee Aquarium when the tanks were full of scuba divers scraping all the surfaces with abrasive cloths and stiff-bristled brushes. The water was full of junk and photography was impossible. In such a situation,

Hammerhead shark photographed with TTL flash at Chattanooga Aquarium. Low light level, constant subject movement, and distortion and reflection because of the acrylic were the problems faced. This was the most successful shot in a series of about 20. It still doesn't satisfy me fully.

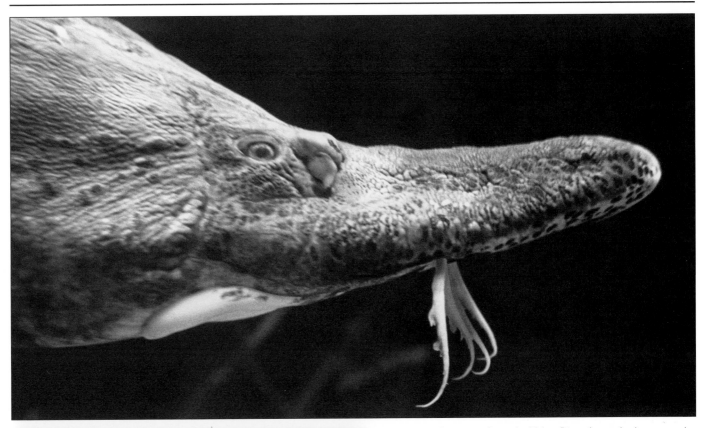

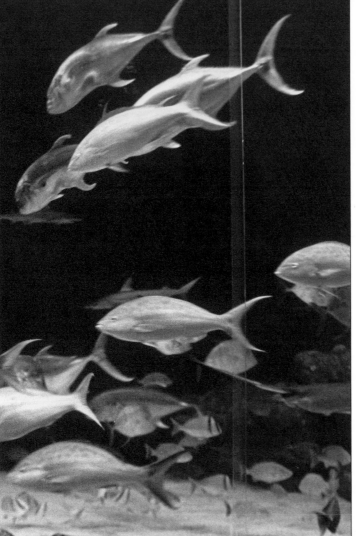

Top: Beluga Sturgeon from the Volga River. A tough shot to make because the fish was constantly on the move. Besides the obvious difficulty of getting the fish in focus, that meant that distortion and reflections in the acrylic tank were constantly changing and therefore unpredictable.

Left: Where water is held behind the great containment strength of acrylic, photographic problems abound. The most obvious problem is the seam where two acrylic panels of unequal optical density join. Other problems include a general softness of focus because of how acrylic passes light, distortion, reflections, and the inability of some autofocus mechanisms to see through the acrylic to focus on the subject inside.

just enjoy the view or shoot the divers.

Distortion is inherent in any containment medium. The cheaper the glass, the worse the distortion will be. Did you ever try to shoot a picture of a praying mantis inside a glass jelly jar? You can't make a crisp shot because of the container. But put the mantis in a small aquarium with flat glass sides and you can make a nice image.

Glass in small aquariums doesn't usually create the distortion problem that acrylic causes in large commercial aquariums. Large commercial aquariums use thick acrylic to contain the thousands of gallons of water their creatures live in. There's a lot of weight there. Acrylic is strong as can be and great for visitors to look through, but it can be a real photographic problem.

If you're shooting video, the ripples in acrylic or cheap glass will become an obvious problem because of the distortion that moves with you as you scan across the face of the container. It's less of a problem with still photography because you only have to find one position that will give you clarity.

Acrylic distorts like crazy and adjacent panels will have different optical qualities. Let's face it, the containments were made for holding tons of water, not for high quality photography. Yes, the designers and manufacturers had to create a containment medium that visitors could see through, but my guess

is that they chose to emphasize strength over optical clarity.

The seams where two acrylic panels meet are sometimes very obvious, but you might forget about them in the fury of shooting. The solution: keep your wits about you and shoot between the seams.

A particularly vexing distortion problem with acrylic is that the acrylic is sometimes scratched by creative visitors and must be buffed out by maintenance people. These

Keep an eye out for interesting shots that include people. At the Chattanooga Aquarium, a spectator makes a nice silhouette against a tank containing jellyfish. Notice the reflections in the tank? I thought I saw them all and avoided them when the picture was made. Guess not.

buffed out areas are of different density than the surrounding material, and thus they distort differently. Watch out.

Reflections come in two flavors: those that are already there and those that you cause.

If reflections are already present, you can try to minimize them by changing your shooting angle or going for tighter picture composition. It might be possible to block the source of an existing reflection with your body. Play with it and see what happens. Sometimes you succeed; sometimes it's just an impossible situation.

At least you can see existing reflections. But reflections you cause will show where you don't expect. It happens mostly with flash.

If you shoot a flash at a 90-degree angle to a reflective surface (glass or acrylic), it's going to come right back at you in an overwhelming glare. We've all done it once, and it's just no good unless you're trying to make a point like I did. The photographic principle here is that the angle of incidence equals the angle of reflection. In simple terms, what you throw is what you get back. This problem can be defeated by simply changing the angle of the shot.

By changing the angle you might be introducing optical distortion through the glass or acrylic. What to do? Get the flash off of your camera. Some camera manufacturers make extension cords for their TTL flash units. If not, you can probably make something up that works with bits from a photographic supply catalog. By

The mountain lion enclosure at the Western North Carolina Nature Center is the home of a pair of beautiful and impressive felines that shouldn't go unphotographed. Access is limited to a glassed-in observation area where reflections are a real problem, as you can plainly see. By putting the front of your lens right up against the glass, the reflections can be defeated, and great photos of mountain lions in a natural habitat are the result.

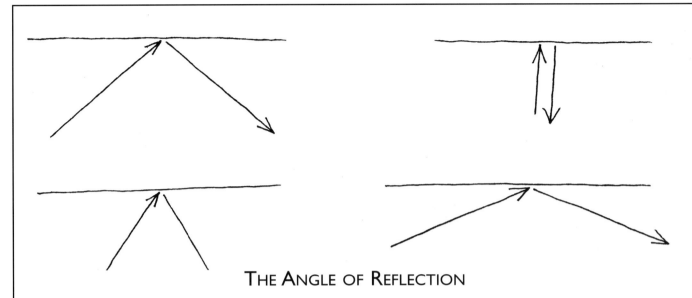

THE ANGLE OF REFLECTION

The angle of incidence equals the angle of reflectance. This means that light bounces off a surface at the same angle as it hits. To prevent reflections from glass, shoot at an angle to the glass.

shooting head-on to the surface and angling the flash, you reduce both the flash reflection and optical distortion.

If you're going to use flash, modeling or focusing lights help to show problems early. This won't be an issue in private homes or pet shops, but most nature centers and commercial aquariums won't allow an amateur to bring in studio lighting equipment. Too much bother and liability, I guess.

One possible answer is to go ahead and use your smaller portable flash unit, but tape a small penlight to it so you can see where the light is going to go. This may take some experimentation to find a way to mount the penlight at the correct angle, but it's a simple way to work around what seems to be an insurmountable difficulty at first glance.

I've also used baffles built of foam-core mount board to

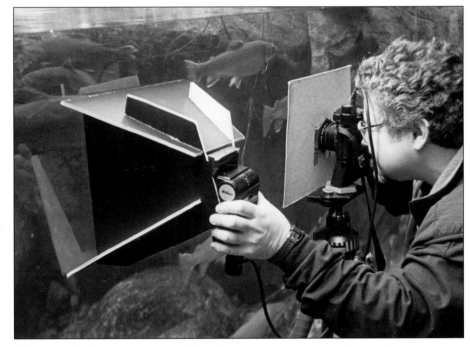

direct flash output. Charles Laun described the technique in his book *Handbook of Nature and Scientific Photography*. It took a bit of fitting with a razor knife and a lot of duct tape, but it worked very well. All the light output from the flash goes into the tank, not bouncing all over the place out of control.

Herptile specialist Charlie Green is using a flash baffle and TTL flash to shoot pictures of a trout at the Tennessee Aquarium in Chattanooga. A flash baffle built to direct all the flash's output into a tank is recommended by Charles Laun (Alsace Books). It takes a while to figure out and build but it puts all your light where it's needed and reduces unwanted and uncontrolled reflections to zero.

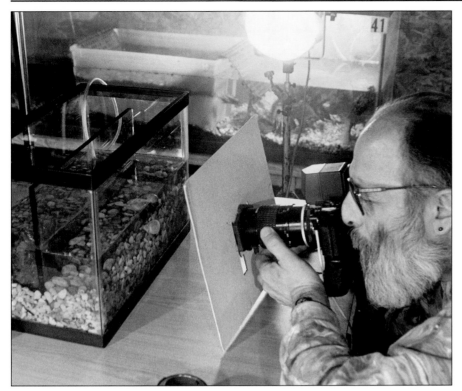

Shooting a small tank lit from both sides. Reflection Killer on front of lens reduces the possibility of seeing the name "Nikon" reflected in the aquarium glass.

"Besides being sexier, a black camera body helps reduce reflections."

Besides being sexier, a black camera body helps reduce reflections. Don't forget to cover the camera manufacturer's name with black photographic tape, too.

Another technique is to use my "Havelin Patented Reflection Killer for the Cokin Filter Holder." A template for it can be found in the back of this book. Make it out of black mount board. Use a new razor knife blade for clean cuts.

Always try to put the front element of your lens right up to the glass surface, but be careful about scratching the surface. A rubber lens shade will help, and of course, you'll need a macro lens for shooting animals in small tanks. Black jeans and a black turtleneck will also help. Always dress ninja for photography in highly reflective environments.

3. Water

Water absorbs light by wavelength. The deeper you go, the less light there is. That's why flash must be used underwater to avoid all the photos turning out green and blue. Luckily, we're not going all that deep in a commercial or home aquarium, so that's one less thing to worry about. The biggest concern for us is suspended particles in the water column.

Did you ever drive through a snow storm or heavy rain at night? Your headlights were on but it didn't seem to help, so you turned your bright lights on. What happened? Your blindness became worse, not better. All that light you were throwing out in front of you just bounced directly back off the flakes or drops in the air. If you were photographing with flash your TTL exposure would be far off the mark and the subject out in front would never have been illuminated in the first place. Too much stuff between you and it. It's exactly the same problem with suspended particles in water.

Once again, the photographic principle here is that the angle of incidence equals the angle of reflectance. Whatever measured angle the light hits a surface at is the reciprocal of the angle the light is going to bounce off from that surface. If you shoot a flash directly at a flat surface, the light is going to come directly back at you. If you shoot at an angle, the light is going to go off somewhere

else. You can figure out where if you're mathematically-minded. The exact angle doesn't matter. What is important is that you can avoid the problem now that you know about it.

How do the particles get into the water in the first place? In a large commercial aquarium like the Tennessee Aquarium in Chattanooga, it might be tank cleaning time and the divers are out working with their scrub brushes. There's lots of water and millions of particles, so it's going to take a while for the debris to settle.

Maybe it's feeding time and the fish are excited. Their feed-ing might break food into small particles that just won't quit.

Suppose a small tank has just been set up for a tabletop photo session. It's going to need time to settle out too, no matter how much you washed the gravel beforehand. This might mean half an hour, or it might mean you shoot tomorrow. It depends on the materials you're using for landscaping.

Of course, finer particles will take longer to settle. This means that for a new set-up, gravel is better than sand. Washing the gravel before putting it in place will help to remove any loose debris and smaller particles.

"It's going to need time to settle out ..."

1. Head-on lighting makes suspended particles blaze like snow lit by a car's headlights. But it's easy enough to avoid.

2. By setting your lights off to the side, you can avoid the "snow storm" effect. Remember, the angle of reflectance equals the angle of incidence.

DEALING WITH SUSPENDED PARTICLES

Top: Queen cell and attendant worker bees.

Bottom: Removing the queen cage from packaged bees before installing in a new hive.

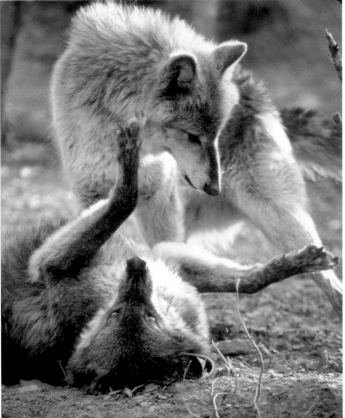

Above: Black-footed cat photographed in repose at Riverbanks Zoological Park in Columbia, South Carolina.

Left: Gray wolves engaged in dominance play at the Western North Carolina Nature Center.

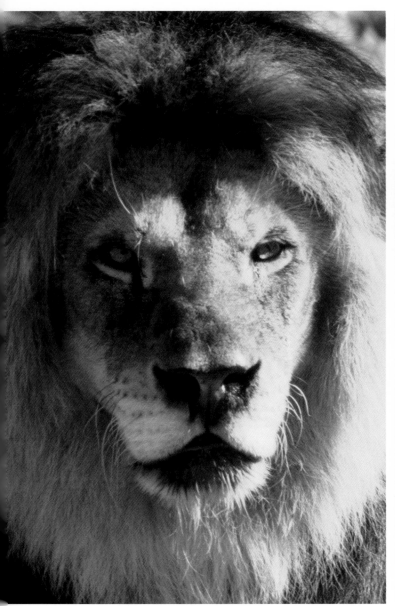

Left: African lion photographed with 500mm lens at Riverbanks Zoological Park in Columbia, South Carolina.

Right: African lion caught in mid-yawn.

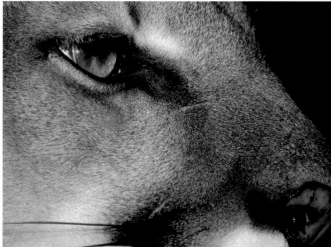

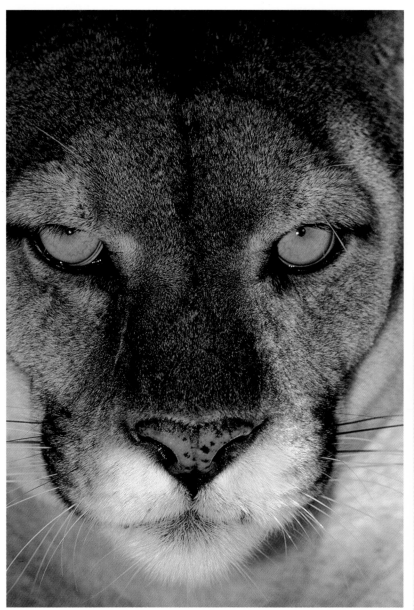

Above: Cougar face frontal shot. Shot in a breeder's compound through a chain link fence using a 200mm macro lens and TTL flash.

Top, Right: Cougar face close-up.

Bottom, Right: Bobcat face.

You'll be able to introduce the creatures and start shooting sooner.

Another way to handle suspended particles is to get your flash off the camera axis. Remember driving through the snow storm? Move the flash head to the side so the particles aren't lit head on.

☐ Animals in Motion
1. Animal Running Parallel to You

If an animal is running parallel to you, it's a panning situation. Panning means swinging your camera to follow the action while keeping the subject in a relatively stable position in the frame and at a constant distance. If done well, this technique shows a crisp animal subject in front of a smeared background. How is it done?

You're in great shape if it's possible to pre-focus on an area the animal will pass through. Use a small aperture to get as much depth of field as possible, but don't use a shutter speed faster than 1/60-second. Good shutter speeds for panning are 1/60 second, 1/30 second, or even slower.

If you don't know where the creature is going, you'll have to rely on your quick reflexes and familiarity with your gear. Experiment with shooting at

Problems Shooting Large Commercial Aquariums & Suggested Cures

• Reflections, reflections, reflections. If you see them, try to avoid them. If you don't spot them before shooting, you'll see them on the light table.

• Suspended particles. Avoid them. Let them settle before you shoot. If you can't avoid them, light your subject from the sides.

• Too dark in tanks for ambient light photography. Use supplementary light, usually flash. Use it as a fill if possible, not as a main illumination. As a main light, all your backgrounds will go black.

• Distortion due to acrylic containments. Find the position with the least distortion and shoot from there. Shoot stills, not video or motion pictures.

• Internal refraction in the acrylic will throw auto-focus mechanisms off. Use manual mode and zone focusing.

• No way to limit creature movements to smaller zone. Always work with a spotter to call the shots as they develop. Learn to shoot with both eyes open: one to the viewfinder and one on the larger environment.

• Crowds of spectators. Be nice and act professionally. People tend to cooperate with someone who looks and acts like a serious shooter.

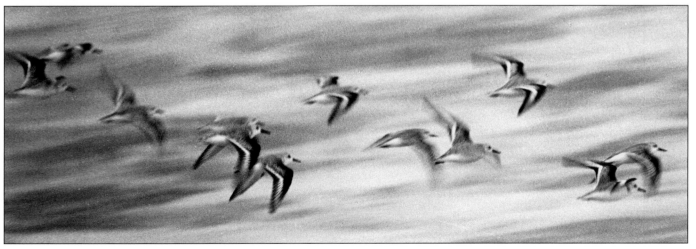

Sanderlings in flight. Not exactly captive animals, but a good example of a panning shot. Background is blurred by camera movement left to right, birds captured clear or blurred depending on speed of flight. Shutter speed was about 1/15 –1/30 second.

cars on the street to get the feel for how it's done and to see the visual effect of different subject and shutter speeds. Film speeds of 100-400 ISO will work just fine.

If your concentration is absolute, your hand is steady, and the gods love you that day, you can make some exceptional shots, but be prepared to waste some film doing it. The end result is generally well worth the effort.

2. Animal Running Perpendicular to You (Toward You or Away)

If an animal is running toward or away from you, the most significant problem is getting a shot of the creature in crisp focus. Remember that the

Panning Shots

- Use film in a speed range of from 100-400 ISO. Faster film won't allow you to use slow enough shutter speeds. Slower film will result in everything being blurred out.
- Faster shutter speeds (1/1000 – 1/250 sec.) will stop the motion and freeze the animal against a crisp background. Slower shutter speeds (1/60 – 1/30 second and slower) will give more problems in catching the creature but will smear the background out of focus nicely and isolate the animal from it. Slower shutter speeds (1/30 – 1/4 sec.) will smear both background and animal and give a highly creative look to the finished shot. This is sometimes visually more striking than a crisply rendered animal.
- A tripod or monopod may help make a pan more level. Be sure the tripod head tracks parallel to animal's path of travel. With lighter lenses like short telephotos or mirror lenses, you should be able to handhold a pan once you learn the technique.
- Before shooting, arrange your feet to the most comfortable position your body will be in at the end of the shot. Without moving your feet, swing your body and begin the shot from the more uncomfortable and awkward end of the pan and follow the action to the more relaxed ending position. This way, your body tension releases through the pan instead of increasing.

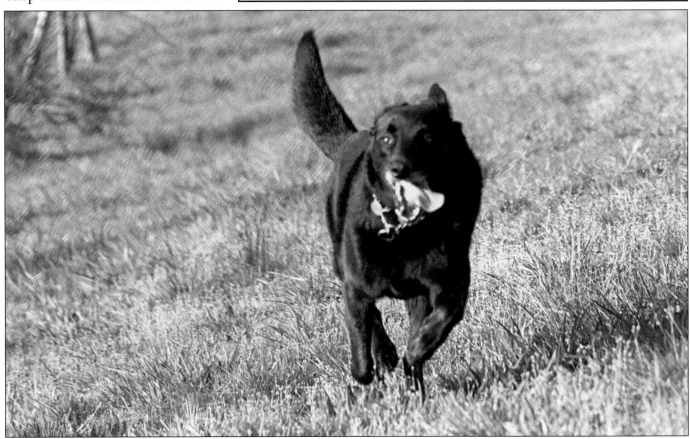

My companion animal Sysop the Self-propelled Dog on the run. He thinks I've got his biscuit.

This zoom lens demonstrates the principle that lenses of different focal lengths have different depth of field at the same aperture. Notice how the focus zone lines on the lens barrel converge toward the longer focal lengths and diverge as the focal length widens the field of view. In practice, at f/8, you have greater depth of field with a 24mm lens than with a 105mm.

can be repeated, use a technique of zone focusing to make the shot. It's basically an ambush. Find a spot that the animal will pass through, focus on that spot using your depth of field preview, then wait for the action to come to you. This is a perfect example of why you'll grow to love your depth of field preview button.

☐ Close-Up Considerations

1. Limited Depth of Field

The basic principle in close-up work is that the closer you get, the less depth-of-field you have. Sorry, but that's the optical physics of it. So what can you do?

More photographic compromises here, and the choice of where to gain and lose is all yours. There are five ways to increase the depth of field for close-ups, none of them a perfect solution. The chart on the next pages details each method, and the compromise you'll make using any given one.

The best method for increasing depth of field in close-up situations is to get more light through the lens to the film. This means using flash. Sorry about the learning curve, folks, but reality is reality. Look at it this way: your photography will improve dramatically and the ratio of keepers to junk will increase.

2. Plane of Focus

A great trick for getting around the problem of limited depth of field is to arrange your subject

face is the most important part. With some of the newer autofocus cameras, this is not so much an issue. For manual cameras, you're going to have to do some fast reacting.

If the animal is under a handler's control and the running

The Close-Up Dilemma:
Proposed Solutions & Resulting Compromises

DILEMMA: THE CLOSER YOU GET TO THE SUBJECT, THE LESS DEPTH OF FIELD YOU HAVE.

How to Get More Depth of Field	Resulting Complication
Shoot at a slower shutter speed.	Can't stop subject movement. Camera movement and mirror slap are more noticeable.
Shoot at a smaller aperture.	Smaller aperture means less light. You have started at a disadvantage and now made it worse.
Arrange the subject parallel to the film plane.	May not provide the best view. Animal subject will probably not cooperate anyway.
Use faster film (higher ISO).	Speed equals grain. The faster the film, the more grain in the final image.
Throw more light at the subject.	Flash is necessary. You must learn how to use it properly.

parallel to the film plane. It works in close-up situations, but also in more normal views of larger objects or scenes. Simply put, apply the principles of copy photography to living things as best you can. In short, minimize the need for great depth of field.

☐ Animal Control & Teamwork

In many aspects of captive animal photography, teamwork is vital. It is at least useful because two people can cover more contingencies than one person. Fewer things are unexpected or overlooked, and less equipment is inadvertently left behind at the shooting location.

The roles of spotter and photographer or handler and photographer are also very useful when shooting. On one shoot at a large commercial aquarium, it was useful for one member of the team to "spot" approaching animals, while the other team member photographed them. Roles were then reversed to provide shooting opportunities for both. In this instance, the spotter would call out, "Shark approaching from your left," or "Spadefish at 3 o'clock." This allowed the shooter to maintain visual concentration through the viewfinder and physical readiness for shooting without having to keep both eyes open or worry about externals.

In the case of reptiles and other smaller creatures, it's plenty for one person to do to keep track of the animal and control its movements. It's virtually impossible for one person to monitor the animal, focus, and expose film at the same time. Someone has to do the animal work while the shooter shoots.

"This allowed the shooter to maintain visual concentration..."

Team shooting is required for anything that isn't stuffed and mounted. Charlie Green is acting as the turtle wrangler while I shoot face shots. If both people want the shots, switch roles.

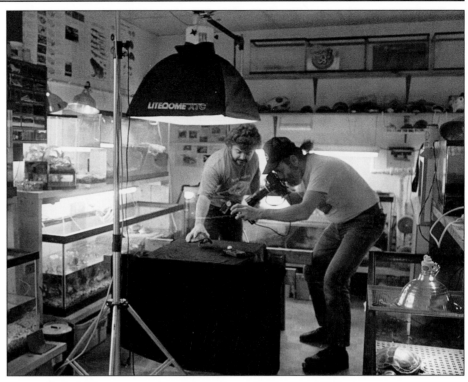

"... that person must be knowledgeable about the animals..."

When working with dangerous animals like poisonous snakes, the handler is a must. Not only must there be a handler, but that person must be knowledgeable about the animals, about their habits and their responses to perceived danger. If possible, the handler should know the personal idiosyncrasies of the particular animal being photographed. This could avoid a medical disaster.

☐ **Crowd Control**

When planning a shoot in a commercial facility, be it a nature center, safari park, zoo, or aquarium, try to plan your photo junket for a weekday morning. At worst, you might have a school trip to deal with, but those kids come with their own paid chaperones. These facilities are mobbed on weekends by kids with parents who can't control them, the curious parents themselves, grandma from Milwaukee, and all their cousins.

If possible, call ahead before going and talk to the public relations office or management staff. Try to arrange a photos-for-access deal that will get you in before or after public hours. That might work in local nature centers, but probably not in major metropolitan area zoos.

If there's no way around it, go whenever you can, but don't go alone. Teamwork is the key. Bring someone to run interference with the crowd. This is a perfect responsibility for your photo assistant (besides keeping an eye on your gear). Above all, be nice to the people you encounter. And you can make some serious karmic points by letting kids (and adults, too) look through your camera to see the enhanced view your high-priced optics provide.

8
SET-UPS

☐ The Case for Standardization

In most human endeavors, a methodical approach is usually more productive over the long haul than a scattered and disorganized lack of method. After the basics have been mastered, variations can be developed to solve specific problems that present themselves.

Photography, being a technical as well as aesthetic field, allows this approach to be used to great effect. Learn a few basic lighting set-ups and get used to them. Learn the basic exposure ranges that they allow you to work in, and learn their subtleties

Using one basic lighting set-up, vary the terrain you shoot in. Apply the same lighting technique to different environments and see what the results look like. When you have an understanding of how it works, start to vary the lighting. Change one factor at a time and study the results carefully. The changes will probably be gross at first, but more subtly will begin to show after a while. With an understanding of one basic set-up, use the same learning approach on a second set-up. Eventually you'll develop a repertoire of techniques that you can mix and match to solve a great variety of shooting problems.

In tabletop work, for example, a basic overhead light with some fill from the front can be productive with many different animals. When you can reliably get reasonable results from what used to be vexing shooting situations, start to play with lighting variations. Try using reflectors to throw light into shadow areas. Use stronger side lighting. Try for night effects.

Don't misunderstand. I'm not saying that all your pictures should look the same. I'm saying that you should get control of your process by learning the capabilities and limitations of several different basic set-ups, what they can and can't do.

"... start to play with lighting variations."

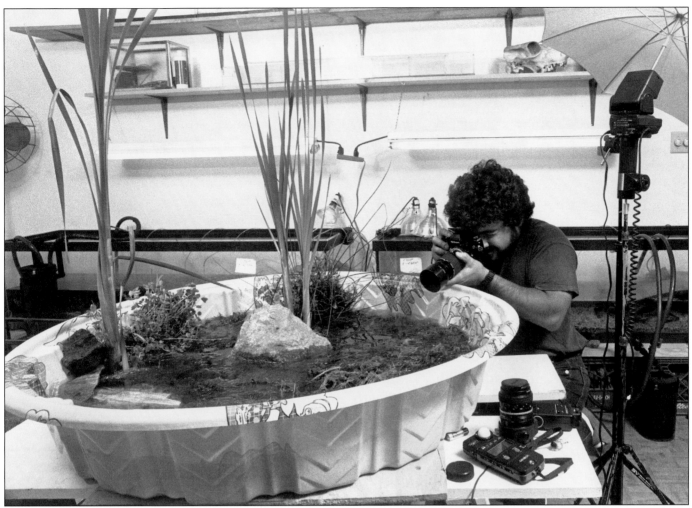

We pondscaped a plastic kiddy pool in Charlie Green's turtle room, lit it with a couple of umbrellas, and added a bullfrog and some turtles. The pictures were remarkable for their "lifelikeness." Weather wasn't a problem, nor was the quality of daylight, nor distance to the shooting location. It was all done at home in an evening's work.

The overall look of your work will improve.

When you talk about controlling the photographic situation, you are talking about studio photography. (Some of you readers just groaned. Don't try to deny it; I heard you.) But I'm telling you straight out: if you want to get good pictures, you can't wait until they fall into your lap. You have to learn to make them on purpose, and that means learning to control the environment in which you're working. In short, you have to learn some studio photographic technique. Wait! Don't panic. It's really not hard to learn the basics you need.

The same techniques that the big New York fashion and product photographers use can be applied to the natural world. This book's purpose is to expose you (that's a photographic joke… get it?) to some of these techniques, to help you understand them and take control of them, with the goal of having you make great images of animals.

We all start out in nature photography by relying on the sun, but let's face it, the sun is out of our control. It's too big to carry around in your camera bag, throws shadows that are too dark, and is an inconsistent light source because of things

like cloud cover and the earth's rotation into night. What can be done? We can start using canned sunlight: flash.

A basic flash unit is considered a daylight source because it produces light that fairly well emulates the color of sunlight. That's why the same roll of "daylight" film can be exposed by sunlight or flash.

Without getting too technical, light comes in various colors. Sunlight tends to be bluish in color, so film manufacturers made film with a built-in reddish filtration to compensate for the bluish cast and render Caucasian skin tones correctly. (Why Caucasian? At the time, there wasn't much in the way of political correctness and they needed to settle on some standard. That was what they chose.)

Tungsten or incandescent lights like photofloods tend to be more reddish, so the film manufacturers have compensated for that and given us self-filtering tungsten film for that too. Don't worry about it too much for now. Just buy daylight film if you'll be shooting with flash. You can use it outdoors in sunlight too, and fill flash won't throw the color balance off.

You can buy big flash units or small ones, huge many-thousand dollar studio rigs with multiple flash heads, $10 units that clip on top of your camera, or sophisticated TTL units designed and built by your camera's manufacturer. For your purposes, they all throw the

Studio Photography Defined

• Just because we're using the term "studio photography" doesn't mean that you'll be shooting everything indoors from now on. For our purposes, a "studio" situation is a "controlled" situation in which you, the photographer, control the quality and direction of the light that illuminates your subject. Thus the term "studio photography" can be used when photographing an indoor set, but it can also be used when photographing an elephant in a zoo and adding some fill flash to brighten up the shadows. You're still taking control of the light and resulting image.

same color light, roughly equivalent to daylight, but in different quantity and with different degrees of controllability. There's no need to invest big bucks right at the beginning. Just start with something small to begin learning and work up to more complex equipment as your understanding increases.

☐ Shooting Big

Shooting big means shooting subjects that are generally zoo inhabitants. We're talking about elephants, tigers, and even creatures like large lizards in glass-fronted desert habitat displays. Or you might visit a raptor repair facility and need to shoot a flight-challenged eagle.

The biggest problem in a zoo shoot is going to be the subject animal's behavior. They tend to be uninformed about and uncooperative with your photographic agenda. Remember that they live first of all on their own internal clocks, then to the zoo's feeding and cleaning schedule. They don't care about your schedule at all.

"We're talking about elephants, tigers, and even creatures like large lizards..."

"Another problem might be the distance between the subject and your lens."

You just have to learn patience. If it takes waiting an hour for the lion to come out of the shade for a sun-lit shot, that's what it's going to take. You have no control.

Another problem might be the distance between the subject and your lens. In such a case, use that long lens that you paid so much for. Shoot as you would if you were in a national park. Don't limit yourself to just one focal length though. Try different focal lengths and even doublers for a variety of shots such as individual portraits, pairs or groups of animals, and animals in their environment.

A third problem is going to be subject illumination. Animals will rest in the shade during a hot day, perhaps even most of the day. They may decide that mottled shade is what they want just when you arrive to shoot. I've had a Siberian tiger pace back and forth from sunlight to deep shade for over an hour. Difficult, to say the least.

How can you control the lighting? With flash. But the $12 flash from the sale bin at K-Mart isn't going to do the job. You need something more powerful, something that is hopefully going to provide TTL exposure with your camera.

One nice piece of equipment to have is one of several gadgets made to throw your flash to a greater distance: the Project-A-Flash, the FlashExtender, or the Teleflash. They allow you to illuminate that rhino reposing in the shade at the extreme limit of its enclosure. I have never used one of these, but I have it from someone whose informed opinion I respect (Len Rue, Jr.) that these things work well TTL camera/flash combinations. Although interested in selling these units, he warned about two possible problems, neither insurmountable. The benefits far outweigh the dangers.

The first problem is that they are all designed for use with lenses of 300mm focal length or longer. Because these gadgets are supposed to focus the flash output at a distance, the illumination will fall off at the corners of your frame if used with a shorter lens that sees a wider field of view.

The second problem is that they share the same red-eye problem as all on-camera flashes. The solution is to mount the flash and projecting fresnel lens off the axis of the camera's taking lens by using an outrigger or gunstock arrangement. Red-eye should then cease to be a problem.

☐ Shooting Small

The next section deals with photographing anything small enough to be shot on a table-top. That could be anything from a cat, squirrel, or rat on down. It might include something a little bigger but which has to be dealt with in a totally controlled situation to get the photographic result you're after, even a three-foot long Savannah lizard that has to

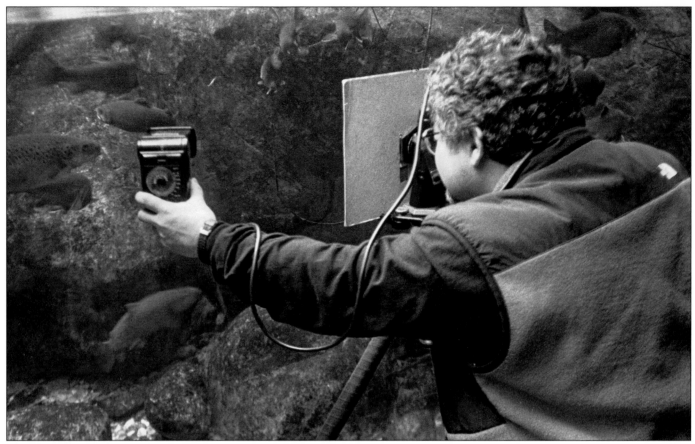

be lit well for that essence-revealing portrait.

☐ Several Basic Flash Set-ups

1. Set-up #1 – TTL on a Cable

For me, this is the most basic of approaches to flash photography. It consists simply of a TTL flash designed to work with my camera by the manufacturer. As discussed earlier, the TTL flash and camera communicate to determine proper exposure. It's perfect for flash fill, or for main illumination where you want the background to render subdued or flat black.

The only addition, but perhaps the most important element here is the three-foot cable between the flash and camera. Flash mounted directly on the camera is a no-no. It pro-duces two effects that are not wanted.

The first problem is commonly known as "red-eye." Red-eye is the phenomenon that all owners of point-and-shoot cameras eventually groan about. Light from the flash bounces off the retina of the subject's eyes and comes directly back to the camera lens. They sell little pens to remove the red-eye from your prints, but if you shoot slides, it's there forever. How to prevent it? Get the flash axis off the lens axis. Remember that the angle of incidence equals the angle of reflectance? Same old principle. My three-foot flash cord saves the day.

The second problem is that flash on camera generally pro-

A three-foot long TTL flash cord moves flash off the camera lens axis. This prevents red-eye and allows modeling of the subject.

duces a flat frontal lighting that makes things look two-dimensional. By moving the flash off the lens axis, it's possible to get some modeling effects, especially when working with two light sources: the sun and the TTL flash. Now, three-dimensional objects can be rendered to look truly three-dimensional.

2. Set-up #2 – Single Overhead Flash

With smaller tanks, if there's no space in which to work or for some other reason a more elaborate set-up isn't possible, try shooting with a single TTL flash set high over your subjects. This is particularly practical if the tank gravel is white and can

act as a reflector to throw some light back up at the subject from below for fill.

If there's room above, try using a flash in a softbox of some sort to make the light a bit less harsh. Even though water will diffuse the light itself, a softbox may help.

3. Set-up #3 – Dual Side Lights

This set-up uses two lamps aimed into the set from the sides. It's particularly good with small aquariums, since it throws plenty of light into the set, but it minimizes reflection from the tank's front and back surfaces. The light stands can be set a bit forward and the lamp heads angled back into the tank. This

Hermit crab photographed with one TTL flash fired from above the tank.

provides a bit more frontal lighting. (Always remember that the angle of incidence equals the angle of reflectance.)

A back light might be nice to add for some rim lighting to set the subject off from the background, or reflectors could be used to brighten up deeply shaded areas.

4. Set-up #4 - Zone Lighting

This set-up can be used with medium-sized tanks (10-50 gallons) or in large public aquariums. These sized tanks are usually found in people's homes, restaurants, or perhaps even at a fish breeder's facility. The principle is the same anywhere. One advantage of

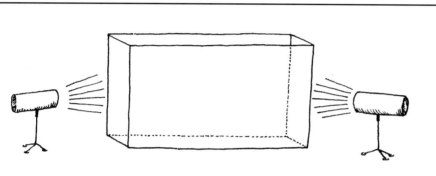

Lights placed to the sides of a small tank will not create unwanted reflections. Angle the lights slightly toward the back of the tank. Experiment by placing one light more forward, the other further back.

DUAL SIDE LIGHTS

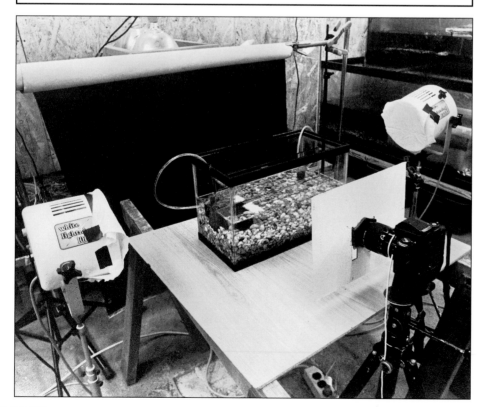

Set-up #3 – Dual Side Lights. These White Lightning flash units were too powerful for the distances involved, so the light output was softened by two layers of diffusion material on each lamp. One unit was fired by sync cable attached to the camera; the other was slaved to fire simultaneously.

Zone Lighting Problems & Proposed Solutions

Problem	Proposed Solution
Lighting the wrong zone. Subjects won't enter your well-lighted trap.	Before setting your lights, watch the animals (usually aquatics with this set-up) to see which areas the animals frequent. Light those areas.
Determining exposure.	1) Mount the tops of a Kodak film cassette container (18% gray) on a wand. Insert it into the zone, and measure exposure with your spot meter.
	2) Shoot a 24-exposure test roll of slides, get them processed and evaluate the results. Use the best exposure as a base.
Controlling subject movement.	Build a glass or clear plexiglass movement limiter to keep the subject in your perfectly lit zone.

In small aquaria, use easily constructed glass containments to limit subject movement within the larger environment. Build them no more than 6-7 inches on their longest side. Contain the swimming subject and fire away.

GLASS LIMITERS TO CONTROL SUBJECT MOVEMENT

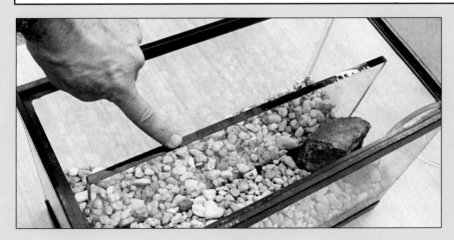

A glass plate inserted into the gravel and supported from behind by a decorative rock serves to limit the depth of the area in which an aquatic subject can travel. This simplifies lighting (smaller area to light), and reduces the problem of following focus on an active specimen.

working in a private home is that light stands can be set up and left in place while waiting for that all-important diagnostic first roll of slides to come back from the lab. You won't be able to do that in a public commercial aquarium.

The concept is simple: light a zone or area within the larger volume and wait for your quarry to enter the zone, then shoot. It's another time-consuming shooting process, and it can be very frustrating, but if it's done well and you are sure of your exposures, you can get some great shots.

5. Set-up #5 – Overhead Main Light With Reflector Fill

This lighting arrangement is one that is used by high-priced advertising photographers for shooting almost anything from miniature perfume bottles to automobiles. It consists of one main overhead light in a softbox, with this main illumination being supplemented by reflectors which throw light back into the set for fill. It's simple, controllable, and can be highly dramatic, if that's what you're after.

You can also add a back light if you want. Aimed at the subject from behind it will create a rim light, a bright edge that outlines the subject. Aimed at the background it will create a light pattern which will also separate the subject from what's behind it. Play with it and see what it does.

Overhead main light simulates sunlight. The reflectors throw enough light back in for fill. For reflectors, use white card or even tin foil that's been crumpled up, flattened again and stretched over cardstock for support.

OVERHEAD MAIN LIGHT WITH REFLECTOR FILL

6. Set-up #6 – Open Pit With TTL Fill

For shooting snakes and lizards with the help of a handler, try this. Use an open-topped container such as a kiddy swimming pool or four-foot square plastic storage box with sides no higher than six to ten inches. Landscape it with sand, gravel, or small plants to simulate a natural environment. Set your main overhead light and measure the illumination with your flash meter. Adjust your exposure reading so that the film would be underexposed by one-half to one full stop. Use that as an ambient light base from which to calculate your frontal fill. Use the TTL flash attached to your camera for the

fill. This will have the effect of reducing the visual emphasis on the background and properly exposing the creature. Works every time.

When working with frontal fill like this, I usually slave the overhead light so that it fires in response to the frontal TTL flash without me worrying about synchronization through a web of cables.

A TTL frontal fill works beautifully with an overhead main light. Measure your exposure using the overhead as a base. The fill takes care of its own exposure working on TTL via a sync cord to my camera. The overhead fires by slave.

MAIN OVERHEAD LIGHT WITH TTL FILL

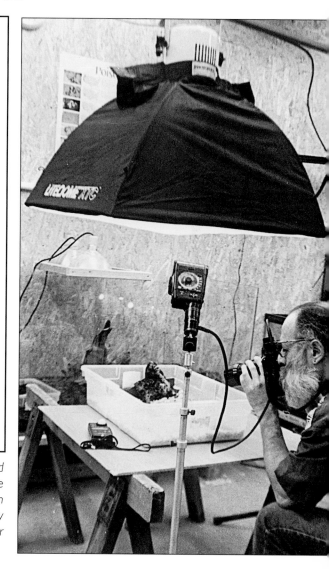

Here's a photo that's packed with how-to information. The main light is the overhead Lightdome. I metered for it and set my camera accordingly. The Nikon TTL flash in the center of the picture is actually for fill, and is connected by cable to the camera. When the shutter was released, the Nikon flash on the cable fired, followed immediately by the slaved overhead main light. It's a little different way to do it, but the result was fewer cables to get tangled in.

9

A Real Life Shoot

Okay, the theory's all out of the way. Now let's see how it actually works. For this demonstration junket, I'm going to use my trip to the Wild Animal Safari in Pine Mountain, Georgia. I had such a great time there that I think all y'all should go. Let's get started.

It began with a phone call. I heard about a safari park with lions and giraffes, so I asked around and a friend at an area nature center finally gave me a number. I called and asked to speak with someone in authority. The first call netted me a woman who said she was the manager. I explained this book project to her and she said she'd pass the info on to the general manager, Curt Snider.

After several weeks had passed with no response, I tried again. Referring to the notes made during my first call, I asked for Mr. Snider. He came on the line and I was instantly snowed. This guy sounded like a character, pure Georgia through and through. He turned out to be just that.

He also turned out to be extremely dedicated to his animals' well-being and an educator of sorts, who saw as his mission to give a close-up experience with animals to as many kids as he possibly could in his lifetime. He didn't exactly say all that word for word, but that's what I gleaned in my conversations with him.

He was concerned about my political agenda and the possibility that my pictures might be used against his park, so I reassured him and offered to write a letter explaining the purpose of my proposed photography at his facility. With that decided, the second phone call was over.

I wrote the letter, giving the name of my publisher (Amherst Media, Inc.), the title and thrust of this book, and promised that I wasn't out to give him bad publicity. I called again about a week after sending the letter and was given permission to shoot.

"It began with a phone call."

Above: Hamadryas baboon male being groomed.

Right: Banded cleaner shrimp shot in a salt water aquarium.

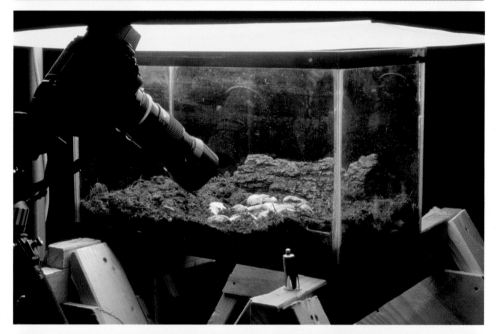

Top: Copperhead fangs.

Center: Photo set-up for snake eggs during hatch.

Bottom: Amelanistic corn snake shot showing ruler for scale.

Above: Burmese python head shot.

Right: Burmese python skin. Always shoot details when they present themselves.

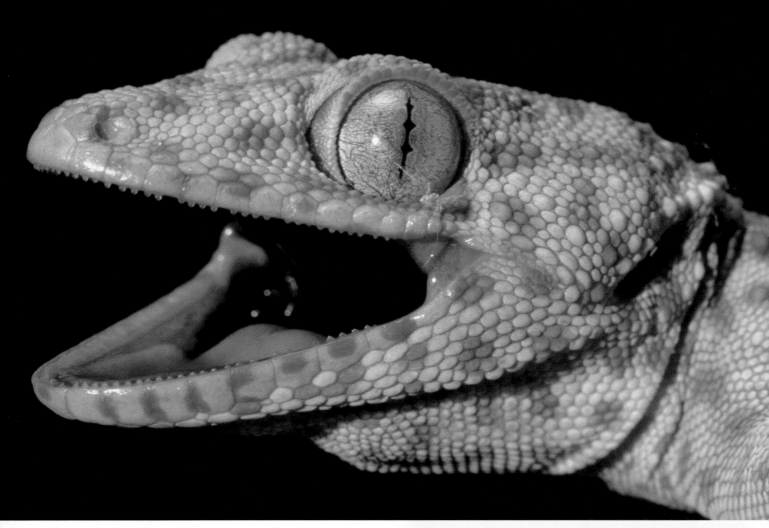

Above: Tokay gecko head shot. Notice the depth of field problem. The eye is in focus but the far edge of the jaw is not. The closer you get, the less depth of field you have.

Right: Praying mantis shot with one flash in a 5-gallon aquarium landscaped with a few garden clippings.

We set a date several weeks hence.

A couple of days before the shoot, I called to confirm my trip. Sometimes they manage to forget, but everything was set. And last, the evening before going I checked the weather report. Clear the next day. Great.

□ Preparation – Subject Research & What to Bring

Preparation is the key. If you plan for everything you can think of, you'll meet only a few surprises instead of being overwhelmed by lots of them. In this case, preparation was fairly sim-

ple. It meant getting my gear together and having enough film. Since my publisher wanted mostly black-and-white for this book, I planned to shoot Tri-X film. A couple of weeks before the shoot I'd bought a 100-foot roll and loaded it into cassettes there were still about fifteen rolls left. That should be plenty.

As for equipment, let's see… two Nikon F3 camera bodies with motor drives, a motorized Nikon FA body for back-up, and a few lenses. When listing the lenses you think you'll need, it's always a good idea to start at one end of your focal lengths and go to the other. It helps to

A tripod may be impossible to use when shooting from cars. Use a "beanbag" type of camera support. This zippered cloth bank money bag was filled with dry rice. Its amoebae quality allowed it to "flow" to rest atop the window's edge and comfortably supported any medium weight telephoto lens.

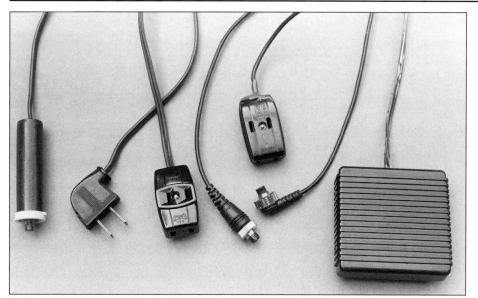

Havelin Universal Interface Remote Firing Cable System. A homemade cable system made up from bought cables and miscellaneous parts. Mix and match as required by various situations. For greater length, insert ready-made off-the-shelf electrical extension cords as needed. Left to right: push button contact switch in Polaroid coater container with male lamp cord end, male extension cord end, female extension cord end, Nikon motor drive trigger cord end, female extension cord end, Nikon motor drive trigger cord end, and Radio Shack foot pedal with lamp cord male end.

think in an orderly way sometimes. How about the 50mm? Nope. 105mm? Yep. 135mm, 200mm, 300mm, and 500mm? Yes, to all of them. And both my doublers: 2x and 1.4x. Tripods? I always have a couple in the car, so that was a given.

The park was set up in a drive-through style, so that meant I wouldn't be able to get out of my vehicle. Everything had to be shot from inside my GMC Jimmy. Because I wouldn't be able to get out and wander around, a tripod was out of the question. I decided to use a beanbag lens support. The one I used was a canvas bank cash deposit bag filled with rice. A similar bag can be made easily and cheaply from a length of old dungaree leg. Cut a 6- to 8-inch length of leg, sew one end shut, and put a zipper in the other. Surely even a bachelor photographer can handle that.

What about meters? I decided on the Sekonic L-368 incident meter because I knew it could be relied upon, and the Minolta Flash Meter IV just because I wanted to compare its readings with the Sekonic.

But the most exciting piece of gear was something else I made up myself: a remote firing cable for the Nikons so I could shoot pictures of myself to show you. It's made from the motor drive connector end of an expensive Nikon cable to which I wired a standard extension cord female plug. I made a couple of firing switches to go with it. One was a Radio Shack foot switch, and the other was just a momentary contact push button stuck in the end of a plastic Polaroid coater container tube. To each, I wired a male extension cord end. You can make the male cords up yourself from parts or just clip the plug wire off a broken home appliance (toaster, hair dryer) that you're throwing out. I've saved a bunch of them and they come in very handy.

The basic rule on what to bring is, if you're ever in doubt about whether to bring a partic-

> "... the most exciting piece of gear was something else I made up myself..."

ular piece of gear or not, bring it. If you don't need it, that's cool. But if it turns out that you do need it and don't have it along, you might have to make another shooting trip. Be prepared.

☐ Scouting the Location

If it's at all possible before the day of the shoot, go and take a look at the places you will be shooting. What you need to see are the physical layout of the place, the location of electrical outlets, controlled traffic flows, and anything else that might impede or ease the shoot. If it's an inside job, take along a camera loaded with color trans-parency film and shoot to determine the color of the ambient lighting.

All of this was pretty well moot in this case. The park was an hour and a half distant, and my first trip would probably be my only trip. Luckily, I've done this sort of thing before, so I had a pretty good idea of what I'd encounter, or so I thought. I was surprised anyway.

As it turned out, I was able to do a quick scout before beginning the day's work. I started from home at 6 a.m. and was waiting at the gate when Mike Miller, one of the partners, arrived to open up. We chatted a bit (he'd been

I like to arrive early. After leaving home at 6am and driving for an hour and a half, final preparation for shooting from my vehicle was done outside the gate before the regular workers arrived.

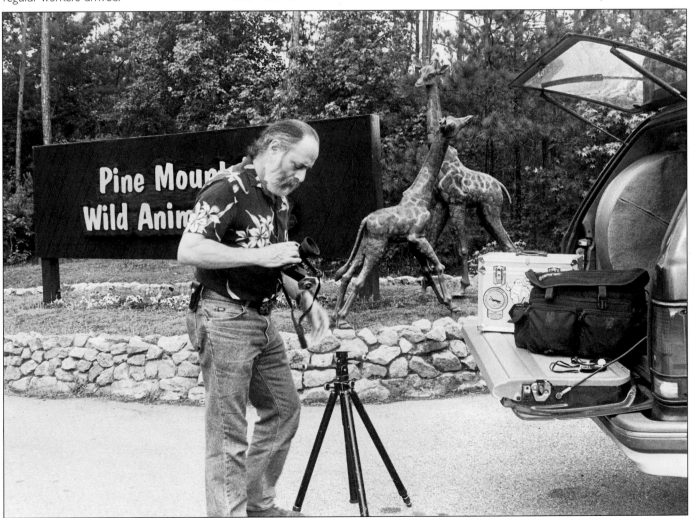

informed I'd be coming) and then he said he was going to take his daily quick look through the park before they opened to the public. I asked if I could ride along. That was my location scouting, and it was great. I got to ride with the guy who ran the place, heard lots of history, some animal anecdotes, was able to see how the place was physically laid out, had animals identified by species and pet name, and learned their hangouts. I was ready.

I'd prepared my equipment for convenient access by setting it on the folded-down back seat. My camera bag full of Nikon glass was within easy reach over my right shoulder. Behind it a short stretch was the aluminum camera box with everything else I might need, including film in self-sealing plastic bags, divided up according to type. A separate bag for exposed film was ready and waiting.

Because the thrust of the trip was to teach others how to do this kind of thing, I had to shoot pictures of myself shooting pictures. While waiting at the gate, I had jammed my Gitzo 320 tripod into a solid position in the front passenger area, topping it with a motorized Nikon F3 wearing a 24mm lens. A remote firing cable ran from it to a foot pedal placed down on the floor in front of my driver's seat. A TTL flash on a 3-foot extension cord was laid on the dashboard. Let's go shoot animals, myself included.

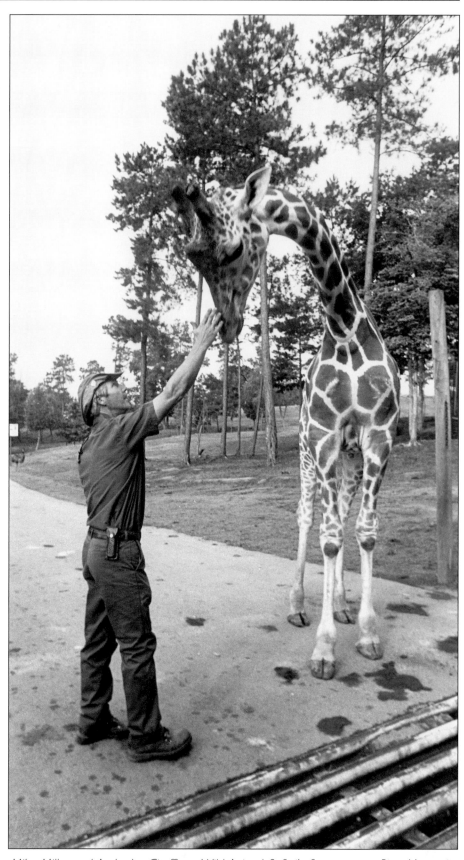

Mike Miller and Andy the Giraffe at Wild Animal Safari's front gate at Pine Mountain, Georgia.

☐ Containing Creatures; Containing Yourself

In a zoo or commercial aquarium setting, containment is all taken care of. In a drive-through safari park, you'll be contained yourself in that your movements will be totally controlled by planned traffic flow and the fact that you can't wander around on foot. In other words, if the animals don't come to you, you're out of luck. That's all right. Creativity is sometimes defined by the limitations imposed on it by outside controls.

☐ Just Do It!

Wild Animal Safari lies on 500 acres of rolling Piedmont Plateau hills in west central Georgia between LaGrange and Columbus. Even in early June, the daytime conditions tend toward the hot and humid. The day was already "hotting up" by the time I was handed a bag of feeder nuggets and turned loose inside the fence. Good thing I'd brought plenty of water along.

The day's experience was incredible! I was astounded by the opportunism of the animals. They came for their handouts, one after another. It was tough to get far enough away from them to get any pure animal shots. Ostriches and rheas were the worst. They would follow the car at the five mile per hour speed limit, blocking my view of the grazers further out from the road. And they all had that predatory bird look. (I think that birds are the true dinosaur descendants, not reptiles. Ever take a good look at a bird's feet? And their personalities and attitudes...)

There were mammals, too, lots of them. The first, just inside the cattle guard, was a

No hand-feeding the lions, please. They were actually contained within separate enclosures in the larger 500-acre environment. If not, they would have probably cleaned out all the boar and ungulates, as well as an occasional tourist.

DO NOT GET OUT OF YOUR VEHICLE

Opposite, Top: Ostriches, emus, and rheas are notoriously aggressive birds, and they're all big enough to do serious damage if they decide to pursue their avian agenda. Don't trust them. They don't think like mammals.

Opposite, Bottom: Prairie dogs pretty much ignored us tourists driving through. They continued to forage and wrestle per normal.

Right: It was tough to get far enough away from some of the animals to make photography possible because they were so well conditioned to hand feeding. They weren't exactly aggressive, just looking for handouts. What a bunch of beggars!

Bottom: Andy the Giraffe astounded the kids and mother in this vehicle by coming in through the sun roof. I could hear them all shrieking with glee.

community of prairie dogs. Several of their communities were scattered throughout the park. Cute little guys. I spotted a couple of fallow deer right away, too. Beautiful but fairly skittish. Later in the day, I was able to hand-feed several of the does: never a buck. Groups of wild boar wandered freely too, and they would follow the car until they realized they weren't my favorites and went to dig something out of a creek bed.

Did you ever hand-feed a zebra? I did. And an American bison too. Wow! What a religious-level experience that was! I'd made pilgrimages out West just to see them, and there I was with a huge bison head trying to push its way into my car window. Wowie zowie!

Andy the Giraffe tried putting his head in too, but it was a totally different quality of experience. He wasn't even from my continent. But he was cool nonetheless. Remarkably gentle. Just watch your fingers on any of these hand-feeding deals. Lay the food in the palm of your hand and let the animal pick it up. Don't hold it out in your fingers. The animal won't distinguish between the food pellet and the fresh meat.

One last admonition. Don't get so caught up in the experience that you forget what you're doing. Remember the principles of photographic composition. Pay attention to your foregrounds and backgrounds. The above shot of two watusi cattle in front of the trailer body is an extreme example. Neat

These Watusi were so impressive that they had to be photographed. But they were in the absolutely wrong place and there was no way to move them. Watch your backgrounds and foregrounds as well as the main subject. This is an extreme example, of course.

Shooting in the Drive-Through Safari Park

- Don't be in a hurry. Park by the side of the drive-through road and watch the animals' lives.
- Use a "bean bag" type rest to support your longer lenses on your window or door frame. Cloth bags can be easily made from the legs of old jeans by cutting them to length, sewing one end shut, and putting a zipper in the other. Bags can be filled with dried beans, rice, sand, or whatever else is dry and at hand. Empty them out for compact storage when the shooting ends.
- When shooting, shut your vehicle off to minimize vibration and thus camera shake.
- Auto window glass can ruin pictures with optical distortion or travel dirt. Try to shoot through open windows or from your sun roof.
- It may be tough to get rid of the animals where they're used to being hand-fed by the tourists. You may have to wait them out. I tried blowing air into a zebra's face and that worked. I wouldn't try that with an ostrich or rhea though. They can be rather aggressive.

picture of the two beasts, but totally useless. I hope it makes the point.

Just before I left, Curt presented me with a souvenir "I got slobbered!" towel. Man, did I ever! Thanks for the whole experience, Curt.

☐ Every Shot a Keeper?

Forget it. No professional shows 100% of what they shoot. Sometimes you'll only get one or two useable shots from a 36-exposure roll. That's all right. When you're working with animals, you're going to have to expose lots of film to get the exceptional shots, sometimes even the barely useable shot.

Don't get depressed about the amount of film that goes through your camera. In fact, considering the time expended in travel, your investment in equipment, the costs of hotels,

food on the road, background materials, and all the effort that's gone into doing your set-ups, film is the cheapest part. So buy some Kodak, Fuji, or Agfa stock and shoot plenty. The more film you shoot, the better chance you have of getting the shots that are the purpose of the whole endeavor.

I'm not telling you to shoot lots and shoot wildly. Quite the contrary. Try to shoot well, as if every shot were the only shot. But animals are unpredictable and uncooperative, so be prepared with more film than you think you'll need, and be prepared to shoot until your shutter finger has a blister. Something good will come from it.

I am an advocate of ruthless editing. When you sit down at the light table to go through the roll that just returned from the

> "No professional shows 100% of what they shoot."

lab, expect to toss most of them out. If a shot is "almost" in focus, that means it's not in focus, so toss it. If the exposure is "almost" right, it's wrong, so toss it. I know it hurts, but do it anyway. If you want, keep all your "outs" in a big box for future culling when you've learned to be more ruthless with your work. But you're going to need a damn big box if you edit correctly.

After a while, your keepers will start adding up. Don't tell people about your cull box. Just show them the good stuff. They'll soon start to think you're a great photographer. The truth might be that you're a great self-editor. That's okay. That's how it's done.

Be proud of your good imagery. Those great shots are what it's all about. Who cares how many rolls it took to get that astounding iguana face shot. You got it, didn't you?

"They'll soon start to think you're a great photographer."

IN CLOSING

You now have the theoretical knowledge to get the animal pictures that you want. Now it's only a matter of practice and miles of film. Start making those phone calls to find the subjects you want to photograph and get going. Life isn't all that long, so you'd better get busy. I waited too many years before I got serious. Don't make the same mistake. Do what you love to do. Make the time for it. Structure your life for your purposes and don't get swept away by overwhelming unimportant distractions (like earning a living).

That's it. Go get 'em. Good shooting.

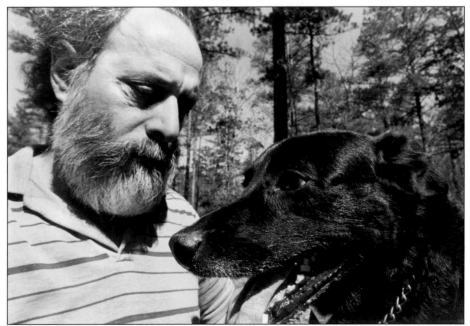

Author Havelin and Sysop the Pizza-Snatching Dog.

GLOSSARY

Ambient Light
Ambient light is all of the light which exists naturally in a scene without supplement by the photographer. This could be sunlight, light from a lamp, candlelight, etc.

Aperture
Opening through which light enters the camera. The size of the aperture controls the depth of field (the smaller the aperture, the more depth of field).

Bellows
An expandable device added between the lens and camera body to allow for close-up work. Bellows move the lens farther away from the film plane, and magnify by focusing only a portion of the total image onto the film plane.

Close-Up Lenses
Supplementary lenses which screw onto the front of your existing camera lens to allow you to get closer to your subject.

Composition
The conscious arrangement of elements within the frame of the photograph.

Depth of Field
Defines the area of sharp focus from you at the shooting position toward the background.

DOF
See, Depth of Field.

Extension Tubes
Rings added between the lens and camera body to allow for close-up work. They move the lens farther away from the film plane, allowing the lens to focus closer than normal.

Fill Flash
Frontal flash used to brighten up areas that would otherwise be in shadow or de-emphasized by lack of light.

Flash Meter
A flash meter differs from a regular light meter in that is able to meter the short burst of light

from a flash unit. *See also*, Light Meter.

Grain

Graininess is an increased appearance of the clumps of silver oxide on a negative, resulting in a speckled look in the print. Increased graininess is common in fast films.

Gray Card

A card which reflects a known amount (18%) of the light falling on it. Metering from a gray card provides accurate exposure information in situations when the subject itself is not of average reflectance.

Incident Light Meter

See, Light Meter.

ISO or ASA

Describes the sensitivity of film to light. The ISO doubles as the sensitivity doubles (so ISO 200 film is twice as sensitive to light as ISO 100 film). Also referred to as film speed.

Light Meter

Light meters measure the amount of light in a scene and allow the photographer to select the appropriate camera settings which will result in correct exposure. There are two common kinds of light meters. *Reflected* light meters (the type found in most cameras) measure the amount of light emitted by or reflected off the subject. A spot meter is a type of reflected meter designed to measure the light reflected from a very small area, yielding a very precise reading of the settings needed to expose that area correctly. *Incident* light meters (generally a hand-held instrument) measure the amount of light falling on the subject.

Mirror Slap

The vibration caused by the movement of the SLR's internal mirror as it moves out of the way during exposure to allow light to strike the film plane. Can cause focus problems.

Modeling Lights

Continuous light source on a studio flash which allows the photographer to see the lighting effect before exposing film.

Monopod

A one-legged camera support used to stabilize a camera while shooting. Not as solid a stand as a tripod, but more portable.

Panning

Intentionally moving the camera laterally while shooting, often to track a moving subject.

Reflected Light Meter

See, Light Meter.

Reflector

A card or (piece of fabric on a wire frame) used to bounce light into the shadowy areas of your subjects. Common colors are white, silver and gold.

Reversing Ring

Allows you to attach the front end of your ordinary lens to your camera, resulting in increased magnification.

Set-Up
Any arrangement of props and lighting for making photographs.

Shoot (noun)
Any photographic adventure.

Shoot (verb)
To capture an image on film; to take or make a photograph.

Shutter Speed
The duration of time during which the shutter remains open and film is exposed to light.

SLR
Single lens reflex camera. A camera in which the viewing lens and taking lens are one and the same so that you see exactly what you are going to shoot without parallax problems.

Spot Meter
See, Light Meter.

Tripod
A three-legged camera support useful for eliminating camera motion.

Viewfinder
The screen on which the photographer previews the image before exposure.

Telephoto Lens
A lens of very long focal length. The angle of view is generally narrower than the angle seen by the human eye, making it useful for shooting distant or small subjects.

Zoom Lens
A lens which is not fixed at one focal length, but which is adjustable to any point in between its maximum and minimum focal lengths.

EXPOSURE TEST CHART

"... always do your exposure tests with slide film."

When using a set-up that can sit undisturbed until your first rolls come back from the lab, use the chart on the next page to determine optimum exposure. Fill it out at the time of shooting and compare it against the results when the film comes back from the lab.

I recommend that you always do your exposure tests with slide film. With slides, you're either right or wrong. There's no leeway for the lab to make corrections. If you shoot color print film, you'll never know the truth. Consumer print lab equipment is designed to make the best possible print from the negative provided, no matter how wrong the exposure might be. This will satisfy Uncle Clyde when he gets his seriously underexposed Easter pictures back, but it just won't help you determine accurate exposures.

When you turn your film in, ask that it not be cut and mounted. It's easier to see exposure differences and relate it to your notes if everything is still in the original order of shooting. You can always mount them later if there's something you want to keep.

When using flash, be sure to check your shutter sync speed first. I also recommend checking it during the shooting session; knobs tend to move when hit inadvertently. If you have a general idea of what the exposure should be from either a meter reading or experience, start there. Then bracket extensively. Shoot a test sequence in half-stop increments up and down from the metered exposure. Write it all down religiously on your chart. When the film comes back from the lab, compare the results with the written record. Then shoot another test roll to refine the exposure.

The chart on the next page is set up for a 36-exposure roll, but for a preliminary test you can just shoot 24 exposures. Even a 12-exposure roll will get you in the ball park.

Exposure Text #				Date:			
Location:							
Film:				ISO:			

Frame #	f/stop	Subject	Lens	Lens extension (if any)	Exposure Results		
					Under	Over	Best
1							
2							
3							
4							
5							
6							
7							
8							
9							
10							
11							
12							
13							
14							
15							
16							
17							
18							
19							
20							
21							
22							
23							
24							
25							
26							
27							
28							
29							
30							
31							
32							
33							
34							
35							
36							

REFLECTION KILLER FOR COKIN FILTER SYSTEM

When shooting at the face of a glass aquarium/terrarium, you might need something to reduce the potential reflections of your camera in the glass. Make and use one of these clever (if I do say so myself) little gadgets. You might still have a problem with the manufacturer's marking on the front of the lens. Those can be covered temporarily with black photographer's tape or permanently with flat black paint. I recommend the tape option.

Use the template on the next page to cut a card that will fit into a Cokin System A Filter Holder. Standard black photographic mount board is the perfect weight and strength. Foam-core is too thick and difficult to cut cleanly, and poster board is not rigid enough.

The overall outside dimensions of the card should be bigger than the template but keep the cutouts to size. If you're shooting with larger front diameter lenses such as are found on medium format cameras, scan the page and scale it up to fit your Cokin System P Filter Holder. This Reflection Killer allows you to use your other Cokin accessories if desired. You'll have to do a little experimenting to make the fit.

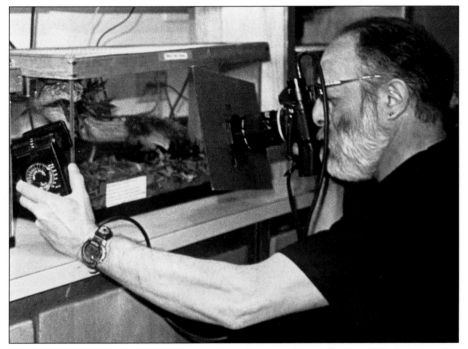

Shooting an amphiuma at the Western North Carolina Nature Center, a TTL flash on a 3-foot cord was held off at an angle to the animal. The pictures were not satisfactory because a second light source or strong reflector was needed on the other side to fill the shadows created by the single flash. Live and learn.

TEMPLATE
Reflection Killer for Cokin Filter System
The overall outside dimensions of the card should be bigger than the template but keep the cutouts to size. If you're shooting with larger front diameter lenses such as are found on medium format cameras, scan the page and scale it up to fit your Cokin System P Filter Holder.

FURTHER READING

ASMP (American Society of Media Photographers) publishes a number of informational books that are updated at intervals as the photographic market changes. Get their current publication list.

The Guilfoyle Report, AG Editions Inc., 41 Union Square West, #523, New York, NY 10003. (212) 929-0959, office@agpix.com. This long-standing news-letter presents current market information for nature photographers. It's a business necessity for anyone interesting in selling their work. The book you're holding was sold because I saw an announcement in *Guilfoyle* that Amherst Media was looking for more how-to photography books.

KODAK Workshop Series, *Building a Home Darkroom*, 1981, Ray Miller, Eastman Kodak Company. How to do it right, from design all the way through to nuts and bolts plumbing. It's an excellent resource.

Brackenbury, John, *Insects in Flight*, Sterling Publishing Co., Inc., New York, 1992, ISBN 0-1737-2594-X. Excellent photography of insects in controlled environments. Not a whole lot on technique but incredibly inspirational. You'll be astounded at this imagery.

Chandoha, Walter, *How to Shoot & Sell Animal Photos*, Writer's Digest Books, Cincinnati, OH, ISBN 0-89879-188-X. Solid advice from one of the guys who's been doing it the longest.

Dalton, S., *Borne on the Wind – The Extraordinary World of Insects in Flight*, Readers Digest Press, London, 1975, ISBN 0-88349-052-8. This was the guy who made it possible for those who came afterwards, like John Brackenbury. Dalton developed the techniques and it was his requirements that resulted in

the invention of the specialized equipment. His work remains remarkable.

Duboff, Leonard, *The Law [In Plain English] for Photographers*, Allworth Press, New York, 1995, ISBN 1-880559-19-6. Stay out of trouble by knowing potential pitfalls along your way. Should be in everyone's photographic reference library.

Freeman, Michael, *The Complete Book of Wildlife & Nature Photography*, Simon and Shuster, New York, 1981, ISBN 0-671-41255-8. This covers lots more than just captive specimens, but there's a really great section on studio work with living creatures. Lots of set-up diagrams.

Haas, Ken, *Location Photographer's Handbook*, Van Nostrand Reinhold, New York, 1990, ISBN 0-442-31948-7. If you're traveling for photography, whether locally or across the planet, this book will solve your problems before they happen. Carry it in your shooting vest's pocket.

Havelin, Michael, *Photography for Writers*, Allworth Press, New York, 1998, ISBN 1-880559-86-2. Practical information on photography, along with how to work with editors and sell text/photo packages.

Heron, Michal, *Stock Photo Forms*, Allworth Press, New York, 1991, ISBN 1-9607118-8-0. All kinds of useful stuff here for the business side of your creative efforts. An important book.

Heron, Michal and Tad Crawford, *Business and Legal Forms for Photographers*, Allworth Press, New York, 1997, ISBN 1-880559-82-X. Vital for survival in a rapacious and litigious world.

Laun, Charles, *Handbook of Nature and Scientific Photography*, Alsace Books & Films, 4849 St. Charles Road, Columbia, Missouri 65201-6760, 1988. A truly magical book packed with practical solutions to photographic problems. This is a great resource for anyone involved with the photography of living things, of all sizes and shapes, wherever they are found. Why don't more people have this on their reference shelves? Because it's self-published and doesn't even have an ISBN. Only available directly from the author.

Maier, Robert, *Location Scouting and Management Handbook*, Focal Press, Boston, 1994, ISBN 0-240-80152-0. Explains everything your need to consider and know before heading out the door, en route, and once you're there. Comprehensive.

McDonald, Joe, *The Wildlife Photographer's Field Manual*, Amherst Media, Amherst, NY, 1992, ISBN 0-936262-07-9.

http://www.hoothollow.com. Joe is an experienced wildlife photographer and workshop leader who really knows what he's talking about. I suggest you not only buy all his books and study them thoroughly, but you might even take one of his workshops. He is a fountain of practical information.

Perweiler, Gary, *Secrets of Studio Still Photography*, AMPHOTO, New York, 1984, ISBN 0-8174-5898-0. This book was written for the advertising photographer, but the lighting set-ups are easily adapted to work with living subjects. It's brimming with clear diagrams of studio set-ups.

Shaw & Rossol, *Overexposure: Health Hazards in Photography*, Allworth Press, New York, 1991, ISBN 0-9607118-6-4. If you're doing your own darkroom work, you need to be aware of the chemical dangers of your craft. This book is vital to your personal well-being.

Shaw, John, *Closeups in Nature*, AMPHOTO, New York, 1987. Primarily concerned with field photography, but much of Shaw's technique is applicable in controlled photographic situations too. Consider this a required book for any nature photography library.

Useful Addresses, Websites and E-Mails

American Zoo And Aquarium Association
http://www.aza.org

Michael Havelin
http://www.mindspring.com/~havelin
havelin@mindspring.com

North American Nature Photography Association (NANPA)
10200 West 44th Avenue
Suite 304
Wheat Ridge, Colorado
80033-2840
(303) 422-8527
http://www.nanpa.org
nanpa@resourcenter.com

Outdoor Writers Association of America (OWAA)
2155 E. College Avenue
State College, Pennsylvania
16801
(814) 234-1011
76711.1725@compuserve.com

Porter's Camera Store, Inc.
Box 628
Cedar Falls, Iowa 50613-0628.
(800) 553-2001
www.porters.com.
A great mail order source for almost anything photographic that you need or can imagine, including cameras and film. True one-stop shopping.

Riverbanks Zoological Park and Botanical Garden
PO Box 1060
Columbia, South Carolina 29202-1060
(803) 779-8717
Well laid out and highly photographable.

L.L.Rue Catalog
138 Millbrook Road
Blairstown, New Jersey 07825
(800) 734-2568
http://www.rue.com
These folks are in the business of providing hard-to-find items specifically of interest to nature and wildlife photographers. Their on-line catalog is extensive. A great source for equipment explanations and recommendations from nature photo experts.

Tennessee Aquarium
One Broad Street
PO Box 11048
Chattanooga, Tennessee
37401-2048
(423) 265-0695
http://www.tennis.org
A magical place that is highly photographable.

Trac Industries, Inc.
26 Old Limekiln Road,
Doylestown, PA, 18901-5534
(215) 345-9311
This seems to be the only place on the planet to buy track-feed 7/16 x 1.85-inch labels that fit perfectly onto 35mm slide mounts. I recommend their product highly. (Check my website for a BASIC language program that will print with these labels on a dot matrix printer.)

Yellow Pages
Locally wherever you happen to be, you can find virtually anything you want in your yellow pages. Let your fingers... You know how it goes.

Zoo Atlanta
800 Cherokee Avenue
Atlanta, Georgia 30315-1440
(404) 624-5600
A cooperative zoo in a major metropolitan center.

INDEX

Other Books from
Amherst Media

Basic 35mm Photo Guide

Craig Alesse

Designed to teach 35mm basics step-by-step — completely illustrated. Features the latest cameras. Includes: 35mm automatic, semi-automatic cameras, camera handling, *f*-stops, shutter speeds, and more! $12.95 list, 9x8, 112p, 178 photos, order no. 1051.

Build Your Own Home Darkroom

Lista Duren & Will McDonald

This classic book teaches you how to build a high quality, inexpensive darkroom in your basement, spare room, or almost anywhere. Includes valuable information on: darkroom design, woodworking, tools, and more! $17.95 list, 8½x11, 160p, order no. 1092.

Into Your Darkroom Step-by-Step

Dennis P. Curtin

This is the ideal beginning darkroom guide. Easy to follow and fully illustrated each step of the way. Includes information on: the equipment you'll need, set-up, making proof sheets and much more! $17.95 list, 8½x11, 90p, hundreds of photos, order no. 1093.

Wedding Photographer's Handbook

Robert and Sheila Hurth

A complete step-by-step guide to succeeding in the world of wedding photography. Packed with shooting tips, equipment lists, must-get photo lists, business strategies, and much more! $24.95 list, 8½x11, 176p, index, b&w and color photos, diagrams, order no. 1485.

Lighting for People Photography, *2nd ed.*

Stephen Crain

The up-to-date guide to lighting. Includes: set-ups, equipment information, strobe and natural lighting, and much more! Features diagrams, illustrations, and exercises for practicing the techniques discussed in each chapter. $29.95 list, 8½x11, 120p, b&w and color photos, glossary, index, order no. 1296.

Camera Maintenance & Repair Book 1

Thomas Tomosy

A step-by-step, illustrated guide by a master camera repair technician. Includes: testing camera functions, general maintenance, basic tools needed and where to get them, basic repairs for accessories, camera electronics, plus "quick tips" for maintenance and more! $29.95 list, 8½x11, 176p, order no. 1158.

Camera Maintenance & Repair Book 2

Thomas Tomosy

Build on the basics covered Book 1, with advanced techniques. Includes: mechanical and electronic SLRs, zoom lenses, medium format cameras, and more. Features models not included in the Book 1. $29.95 list, 8½x11, 176p, 150+ photos, charts, tables, appendices, index, glossary, order no. 1558.

Restoring the Great Collectible Cameras (1945-70)

Thomas Tomosy

More step-by-step instruction on how to repair collectible cameras. Covers postwar models (1945-70). Hundreds of illustrations show disassembly and repair. $29.95 list, 8½x11, 128p, 200+ photos, index, order no. 1560.

Big Bucks Selling Your Photography

Cliff Hollenbeck

A complete photo business package. Includes secrets for starting up, getting paid the right price, and creating successful portfolios! Features setting financial, marketing and creative goals. Organize your business planning, bookkeeping, and taxes. $15.95 list, 6x9, 336p, order no. 1177.

Outdoor and Location Portrait Photography

Jeff Smith

Learn how to work with natural light, select locations, and make clients look their best. Step-by-step discussions and helpful illustrations teach you the techniques you need to shoot outdoor portraits like a pro! $29.95 list, 8½x11, 128p, b&w and color photos, index, order no. 1632.

Make Money with Your Camera

David Neil Arndt

Learn everything you need to know in order to make money in photography! David Arndt shows how to take highly marketable pictures, then promote, price and sell them. Includes all major fields of photography. $29.95 list, 8½x11, 120p, 100 b&w photos, index, order no. 1639.

Leica Camera Repair Handbook

Thomas Tomosy

A detailed technical manual for repairing Leica cameras. Each model is discussed individually with step-by-step instructions. Exhaustive photographic illustration ensures that every step of the process is easy to follow. $39.95 list, 8½x11, 128p, 130 b&w photos, appendix, order no. 1641.

Guide to International Photographic Competitions

Dr. Charles Benton

Take the mystery out of competitions with the information you need to select competitions, enter, and use your results for continued improvement! $29.95 list, 8½x11, 120p, b&w photos, index, appendices, order no. 1642.

Freelance Photographer's Handbook

Cliff & Nancy Hollenbeck

Be a freelance photographer or improve your current freelance business. Packed with ideas for creating and maintaining a successful freelance business. $29.95 list, 8½x11, 107p, 100 b&w and color photos, index, glossary, order no. 1633.

Infrared Landscape Photography

Todd Damiano

Landscapes shot with infrared can be truly breathtaking. The author analyzes over fifty of his most compelling photographs to teach you the techniques you need to capture landscapes with infrared. $29.95 list, 8½x11, 120p, b&w photos, index, order no. 1636.

Professional Secrets of Advertising Photography

Paul Markow

No-nonsense information for those interested in the business of advertising photography. Includes: how to catch the attention of art directors, make the best bid, and produce the high-quality images your clients demand. $29.95 list, 8½x11, 128p, 80 photos, index, order no. 1638.

Lighting Techniques for Photographers

Norman Kerr

This book teaches you to predict the effects of light in the final image. It covers the interplay of light qualities, as well as color compensation and manipulation of light and shadow. $29.95 list, 8½x11, 120p, 150+ color and b&w photos, index, order no. 1564.

Infrared Photography Handbook

Laurie White

Covers black and white infrared photography: focus, lenses, film loading, film speed rating, batch testing, paper stocks, and filters. Black & white photos illustrate how IR film reacts. $29.95 list, 8½x11, 104p, 50 b&w photos, charts & diagrams, order no. 1419.

How to Shoot and Sell Sports Photography

David Arndt

A step-by-step guide for amateur photographers, photojournalism students and journalists seeking to develop the skills and knowledge necessary for success in the demanding field of sports photography. $29.95 list, 8½x11, 120p, 111 photos, index, order no. 1631.

Computer Photography Handbook

Rob Sheppard

Learn to make the most of your photographs using computer technology! From creating images with digital cameras, to scanning prints and negatives, to manipulating images, you'll learn all the basics of digital imaging. $29.95 list, 8½x11, 128p, 150+ photos, index, order no. 1560.

Achieving the Ultimate Image

Ernst Wildi

Ernst Wildi teaches the techniques required to take world class, technically flawless photos. Features: exposure, metering, the Zone System, composition, evaluating an image, and more! $29.95 list, 8½x11, 128p, 120 b&w and color photos, index, order no. 1628.

The Beginner's Guide to Pinhole Photography

Jim Shull

Take pictures with a camera you make from stuff you have around the house. Develop and print the results at home! Pinhole photography is fun, inexpensive, educational and challenging. $17.95 list, 8½x11, 80p, 55 photos, charts & diagrams, order no. 1578.

Stock Photography

Ulrike Welsh

This book provides an inside look at the business of stock photography. Explore photographic techniques and business methods that will lead to success shooting stock photos — creating both excellent images and business opportunities. $29.95 list, 8½x11, 120p, 58 photos, index, order no. 1634.

Profitable Portrait Photography

Roger Berg

A step-by-step guide to making money in portrait photography. Combines information on portrait photography with detailed business plans to form a comprehensive manual for starting or improving your business. $29.95 list, 81/2x11, 104p, 100 photos, index, order no. 1570

Professional Secrets for Photographing Children

Douglas Allen Box

Covers every aspect of photographing children on location and in the studio. Prepare children and parents for the shoot, select the right clothes capture a child's personality, and shoot story book themes. $29.95 list, 8½x11, 128p, 74 photos, index, order no. 1635.

Telephoto Lens Photography

Rob Sheppard

A complete guide for telephoto lenses. Take great wildlife photos, portraits, sports and action shots, travel pics, etc! Over 100 photographic examples. $17.95 list, 8½x11, 112p, b&w and color photos, index, glossary, appendices, order no. 1606.

Restoring Classic & Collectible Cameras (Pre-1945)

Thomas Tomosy

Step-by-step instructions show how to restore a classic or vintage camera. Repair mechanical and cosmetic elements to restore your valuable collectibles. $34.95 list, 8½x11, 128p, b&w photos and illus., glossary, index, order no. 1613.

Handcoloring Photographs Step-by-Step

Sandra Laird & Carey Chambers

Handcolor photographs step-by-step with the standard in handcoloring reference books. Covers a variety of media and techniques with colorful photographic examples. $29.95 list, 8½x11, 112p, 100+ color and b&w photos, order no. 1543.

Special Effects Photography Handbook

Elinor Stecker-Orel

Create magic with special effects! Little or no additional equipment required. Step-by-step instructions guide you through each effect. $29.95 list, 8½x11, 112p, 80+ color and b&w photos, index, glossary, order no. 1614.

McBroom's Camera Bluebook, *6th Edition*

Mike McBroom

Comprehensive and fully illustrated, with price information on: 35mm, digital, APS, underwater, medium & large format cameras, exposure meters, strobes and accessories. Pricing info based on equipment condition. A must for any camera buyer, dealer, or collector! $29.95 list, 8½x11, 336p, 275+ photos, order no. 1553.

Fine Art Portrait Photography

Oscar Lozoya

The author examines a selection of his best photographs, and provides detailed technical information about how he created each. Lighting diagrams accompany each photograph. $29.95 list, 8½x11, 128p, 58 photos, index, order no. 1630.

Family Portrait Photography

Helen Boursier

Learn how to operate a successful portrait studio. Includes: marketing family portraits, advertising, working with clients, posing, lighting, and selection of equipment. Includes images from a variety of top portrait shooters. $29.95 list, 8½x11, 120p, 123 photos, index, order no. 1629.

The Art of Infrared Photography, *4th Edition*

Joe Paduano

A practical guide to infrared photography. Tells what to expect and how to control results. Includes: anticipating effects, color infrared, digital infrared, using filters, focusing, developing, printing, handcoloring, toning, and more! $29.95 list, 8½x11, 112p, order no. 1052

Camcorder Tricks and Special Effects, *revised*

Michael Stavros

Kids and adults can create home videos and mini-masterpieces that audiences will love! Use materials from around the house to simulate an inferno, make subjects transform, create exotic locations, and more. Works with any camcorder. $17.95 list, 8½x11, 80p, order no. 1482.

The Art of Portrait Photography

Michael Grecco

Michael Grecco reveals the secrets behind his dramatic portraits which have appeared in magazines such as *Rolling Stone* and *Entertainment Weekly*. Includes: lighting, posing, creative development, and more! $29.95 list, 8½x11, 128p, order no. 1651.

Essential Skills for Nature Photography

Cub Kahn

Learn all the skills you need to capture landscapes, animals, flowers and the entire natural world on film. Includes: selecting equipment, choosing locations, evaluating compositions, filters, and much more! $29.95 list, 8½x11, 128p, order no. 1652.

Photographer's Guide to Polaroid Transfer

Christopher Grey

Step-by-step instructions make it easy to master Polaroid transfer and emulsion lift-off techniques and add new dimensions to your photographic imaging. Fully illustrated every step of the way to ensure good results the very first time! $29.95 list, 8½x11, 128p, order no. 1653.

Black & White Landscape Photography

John Collett and David Collett

Master the art of b&w landscape photography. Includes: selecting equipment (cameras, lenses, filters, etc.) for landscape photography, shooting in the field, using the Zone System, and printing your images for professional results. $29.95 list, 8½x11, 128p, order no. 1654.

Wedding Photojournalism

Andy Marcus

Learn the art of creating dramatic unposed wedding portraits. Working through the wedding from start to finish you'll learn where to be, what to look for and how to capture it on film. A hot technique for contemporary wedding albums! $29.95 list, 8½x11, 128p, order no. 1656.

Studio Portrait Photography of Children and Babies

Marilyn Sholin

Work with the youngest portrait clients to create images that will be treasured for years. Includes working with kids of all ages, from infant to preschooler. Features: lighting, posing and much more! $29.95 list, 8½x11, 128p, order no. 1657.

Professional Secrets of Wedding Photography

Douglas Allen Box

Over fifty top-quality portraits are individually analyzed to teach you the art of professional wedding portraiture. Lighting diagrams, posing information and technical specs are included for every image. $29.95 list, 8½x11, 128p, order no. 1658.

Photographer's Guide to Shooting Model & Actor Portfolios

CJ Elfont, Edna Elfont and Alan Lowy

Create outstanding images for actors and models looking for work in fashion, theater, television, or film. Includes the business, photographic and professional information you need to succeed! $29.95 list, 8½x11, 128p, order no. 1659.

Photo Retouching with Adobe® Photoshop®

Gwen Lute

Designed for photographers, this manual teaches every phase of the process, from scanning to final output. Learn to restore damaged photos, correct imperfections, create realistic composite images and correct for dazzling color. $29.95 list, 8½x11, 120p, order no. 1660.

Creative Lighting Techniques for Studio Photographers

Dave Montizambert

Gain complete creative control over your images. Whether you are shooting portraits, cars, table-top or any other subject, you'll learn the skills you need to confidently create with light. $29.95 list, 8½x11, 120p, order no. 1666.

Storytelling Wedding Photography

Barbara Box

Learn how to create outstanding candids (which are her specialty), and combine them with formal portraits (her husband's specialty) to create a unique wedding album. $29.95 list, 8½x11, 128p, order no. 1667.

Fine Art Children's Photography

Doris Carol Doyle and Ian Doyle

Learn to create fine art portraits of children in black & white. Included is information on: posing, lighting for studio portraits, shooting on location, clothing selection, working with kids and parents, and much more! $29.95 list, 8½x11, 128p, order no. 1668.

Infrared Portrait Photography

Richard Beitzel

Discover the unique beauty of infrared portraits, and learn to create them yourself. Included is information on: shooting with infrared, selecting subjects and settings, filtration, lighting, and much more! $29.95 list, 8½x11, 128p, order no. 1669.

Black & White Photography for 35mm

Richard Mizdal

A guide to shooting and darkroom techniques! Perfect for beginning or intermediate photographers who wants to improve their skills. Features helpful illustrations and exercises to make every concept clear and easy to follow. $29.95 list, 8½x11, 128p, order no. 1670.

Secrets of Successful Aerial Photography

Richard Eller

Learn how to plan for every aspect of a shoot and take the best possible images from the air. Discover how to control camera movement, compensate for environmental conditions and compose outstanding aerial images. $29.95 list, 8½x11, 120p, order no. 1679.

Professional Secrets of Nature Photography

Judy Holmes

Improve your nature photography with this full color book. Covers every aspect of making top quality images – selecting equipment, choosing subjects, shooting techniques, and more! $29.95 list, 8½x11, 120p, order no. 1682.

Macro and Close-up Photography Handbook

Stan Sholik

Get close and capture breathtaking images of small subjects – flowers, stamps, insects, etc. This is a comprehensive manual full of step-by-step techniques. $29.95 list, 8½x11, 120p, order no. 1686.

Outdoor and Survival Skills for Nature Photographers

Ralph LaPlant and Amy Sharpe

An essential guide for photographing outdoors. Learn all the skills you need to have a safe and productive shoot – from selecting equipment, to finding subjects, to preventing (or dealing with) injury and accidents. $17.95 list, 8½x11, 80p, order no. 1678.

Art and Science of Butterfly Photography

William Folsom

Learn to understand and predict butterfly behavior (including feeding, mating and migrational patterns), when to photograph them and even how to lure butterflies. Then discover the photographic techniques for capturing breathtaking images of these colorful creatures. $29.95 list, 8½x11, 120p, order no. 1680.

Composition Techniques from a Master Photographer

Ernst Wildi

In photography, composition can make the difference between dull and dazzling. Master photographer Ernst Wildi teaches you his techniques for evaluating subjects and composing powerful images in this beautiful full color book. $29.95 list, 8½x11, 128p, order no. 1685.

AMHERST MEDIA'S CUSTOMER REGISTRATION FORM

Please fill out this sheet and send or fax to receive free information about future publications from Amherst Media.

CUSTOMER INFORMATION

DATE

NAME

STREET OR BOX #

CITY **STATE**

ZIP CODE

PHONE ()

OPTIONAL INFORMATION

I BOUGHT *PRACTICAL MANUAL OF CAPTIVE ANIMAL PHOTOGRAPHY* **BECAUSE**

I FOUND THESE CHAPTERS TO BE MOST USEFUL

I PURCHASED THE BOOK FROM

CITY **STATE**

I WOULD LIKE TO SEE MORE BOOKS ABOUT

I PURCHASE **BOOKS PER YEAR**

ADDITIONAL COMMENTS

FAX to: 1-800-622-3298

Name_____
Address_____
City_____State_____
Zip_____ — _____

Amherst Media, Inc.
PO Box 586
Amherst, NY 14226